IMAGES
of America

VERNOR'S GINGER ALE

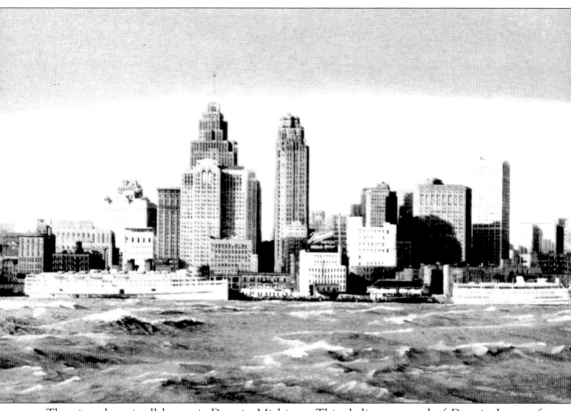

The city where it all began is Detroit, Michigan. This skyline postcard of Detroit, home of Vernor's Ginger Ale, is dated approximately 1945. The illuminated Vernor's Ginger Ale sign is a prominent feature in the skyline. Experts labeled the Vernor's plant as the "most modern bottling facility in the world." Postwar Detroit was booming, and Vernor's Ginger Ale was an important part of the city.

On the cover: What fun the James Vernor Company had with a parade! A delivery truck and trailer were outfitted to participate in a parade in Pontiac. The large Vernor's gnome took a break from protecting the secret ginger ale formula at the plant and rode along. Two "Vernor's Girls" stand with a giant replica of the barrels in which Vernor's extract was aged for four years. The photograph is dated 1924, almost 60 years after Vernor's was first created in Detroit. (Courtesy of the Manning Brothers Historic Photographic Collection.)

IMAGES
of America

VERNOR'S GINGER ALE

Keith Wunderlich

ARCADIA
PUBLISHING

Published by Arcadia Publishing
Charleston SC, Chicago IL, Portsmouth NH, San Francisco CA

Printed in the United States of America

Library of Congress Catalog Card Number: 2007936195

For all general information contact Arcadia Publishing at:
Telephone 843-853-2070
Fax 843-853-0044
E-mail sales@arcadiapublishing.com
For customer service and orders:
Toll-Free 1-888-313-2665

Visit us on the Internet at www.arcadiapublishing.com

*To my mom, who said it was okay for me to keep that box
of old Vernor's bottles from the garage over 30 years ago*

CONTENTS

ACKNOWLEDGMENTS

Detroit is a great city with a rich history of entrepreneurship. It is the grit and determination of our ancestors, against all odds, that lead those of us here now to continue to love and believe in Detroit. Thank you to all those who built this city.

Thank you to all who protect the history of Detroit. My friends at the Detroit Historical Museum, especially Tracy Smith, have been very Vernor's friendly. The staff at the Burton Collection, within the Detroit Public Library, has preserved a wealth of Vernor's and Detroit photographs and history. My thanks go to Allyn Thomas of Manning Brothers Historic Photographic Collection and Jack Deo of Superior View for their great resource of Vernor's images. Many thanks also go to Steve Kleeman and Tony Dearing of the *Flint Journal* for access to their photograph archives. Sharna Smith from the Arcadia Township offices was also most helpful in providing images for this book. Mike Novak, another person with the same Vernor's obsession as me, was very generous in loaning me photographs from his collection. Thank you, also, to Ron Bialecki, who played the part of the Vernor's gnome starting in the 1970s and loaned some images for this book.

Anna Wilson, my editor at Arcadia Publishing, has been very helpful. She always found a nice way to say, "That photograph isn't good enough for this book." Her sense of humor and encouragement has been appreciated.

This book could not have happened without the support of Cadbury Schweppes, owners of the Vernor's brand. I would like to thank Terry Hockens, Doris Lucas, and Joe Janaszak for their enthusiasm about Vernor's and for cutting some corporate red tape to be able to write this.

Finally I would like to thank my family. To my kids, Dave, Sarah, Bob, and Dan, thank you for not complaining as I dragged you to numerous antique shows and flea markets over the years in search of the next Vernor's collectible. To my wife, Mary, your support of my Vernor's hobby, this book, and me is wonderful.

INTRODUCTION

Over 140 years ago, James Vernor served the first glass of Vernor's in his pharmacy at 235 Woodward Avenue in Detroit. The story of James Vernor is as complex and interesting as the secret formula for the soda. James Vernor was not just a man who invented a soft drink. He was a leader and one of Detroit's most admired citizens.

Higby and Stearns Drug Store was where young James Vernor had his first job as an errand boy. He began working there in 1858 with all the spirit and enthusiasm that a 15-year-old would have. He made quite a name for himself due to his parcel wrapping and fast deliveries. He was soon promoted to the position of junior clerk.

Vernor stayed with Higby and Stearns until the age of 19, when he enlisted in the 4th Michigan Cavalry. In July 1865, he was discharged and returned home to Detroit. Almost immediately after his return home, he opened a drugstore at 235 Woodward Avenue.

Vernor was admired as a pharmacist. He closely scrutinized his prescriptions for quality, accuracy, and possible drug interactions. Vernor was meticulous about his work. Everything he did needed to meet his high standards. He served on the state board of pharmacy for eight years and was one of the driving forces to pass the state's first pharmacy law. He held Michigan's pharmacy license No. 1 all the years he practiced. Like all good pharmacists, Vernor also had a soda fountain in his drugstore.

There are conflicting stories about how the ginger ale first began. The most popular story, and one found frequently in the James Vernor Company's own literature, says that Vernor began experimenting with a formula for ginger ale prior to leaving for the Civil War. Upon returning from the war, he opened a wooden cask of his extract and found the taste he had been hoping to discover. The secret combination of ingredients, along with the four years of aging in wooden casks during the Civil War, perfected his ginger ale and gave it the "deliciously different" flavor. Another story says he began experimenting with his formula after returning from the war.

The second James Vernor came into the business in 1896. The drugstore was closed and a small plant established at the foot of Woodward Avenue, many blocks south of his former drugstore's location. The plant was devoted to the blending, aging, and bottling of Vernor's Ginger Ale. Also that year, a horse and light wagon were purchased for distribution purposes. In the beginning, the father-and-son team were the only employees. They often worked 16-hour days together washing bottles, making and bottling the ginger ale, delivering it to various sites in the city, and taking care of clerical duties.

Vernor's grew as Detroit grew. The next 20 years would see tremendous expansion of the plant and distribution area. Picture the scene: the foot of Woodward was the location of the docks for

commuters taking ferries to Windsor, Ontario, and the Bob-lo and Belle Isle boats. Excursion boats also docked nearby. Thousands of thirsty passengers stopped daily at Vernor's fountain for a refreshing taste of ice-cold Vernor's Ginger Ale. Vernor's huge illuminated sign lit up the waterway between two nations and the skyline of a major city.

The demand for Vernor's was huge. Every first-class drugstore in Detroit installed dispensing equipment specifically to serve Vernor's. Hospitals began utilizing it more, and thousands of cases were being delivered to homes.

The same standards that had been applied to the consistency of his prescriptions were applied to the consistency of Vernor's Ginger Ale. The water had to be specially purified. The blending needed the finest Jamaican ginger distilled in the absolute proper proportion with other fruit juices. Even the carbonic gas used was produced by Vernor so it would meet their requirements.

It was about that time that the two Vernors decided a great way to expand the business even more would be to produce the extract for sale to franchise holders. The expansion of their plant illustrates how successful this idea and strategy was. In 1918, Vernor purchased the old Riverside Power Plant. In 1919, a six-story main building was erected adjacent to the other two. In 1939, the 10-story Siegel building was purchased and renovated. In 1941, the "most modern bottling facility in the world" was completed at 239 Woodward Avenue.

James Vernor II had a son, another James Vernor. James Vernor III also had a son, James Vernor. Yet, the company did not pass on to either one of them. It is impossible to predict if the company would have remained in the family if either had been president. J. Vernor Davis, the grandson of the founder, took over the presidency of the company.

The James Vernor Company had always been a family-owned company. The death of James Vernor II forced the company to sell some stock to the public. In the late 1950s, Vernor's became Vernors. (Note the lack of the apostrophe between the r and the s.)

In 1966, the 100th birthday of the James Vernor Company, Davis became chairman of the board. That same year, Vernors was sold to a group of investors, members of the New York Stock Exchange. It was simply the first in a number of sales.

Again in 1971, Vernors was sold to American Consumer Products. By 1979, another company, United Brands, owned Vernors. This ownership would be the one most costly to the city of Detroit. In January 1985, Cincinnati-based United Brands abruptly ended bottling operations at the plant. An apartment building for Wayne State University is now on the site.

Just two years after abandoning Detroit, United Brands sold Vernors to A&W Brands. All of A&W was subsequently purchased by Cadbury Schweppes Americas Beverages. In 1996, Dr Pepper/Seven Up merged with Cadbury Schweppes Americas Beverages and moved to Plano, Texas. A&W Concentrate Company owns the Vernors brand.

The plant is gone. The huge illuminated sign is gone. The fountain at the foot of Woodward Avenue is gone. But many Detroit hearts are warmed with the fond memories of a man, his ginger ale, and the mark he left on his city.

One

THE EARLY
ENTREPRENEUR

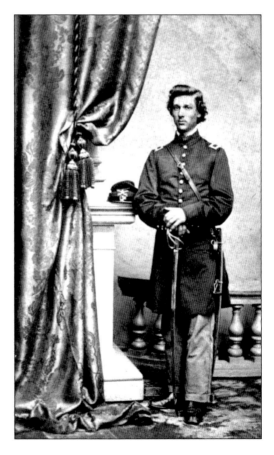

The story of Vernor's Ginger Ale begins
at the start the Civil War. James Vernor
was part of the 4th Michigan Calvary. The
medical knowledge he gained from his
teenage job working for a druggist was used
on the battlefield. He served as a hospital
steward. During one battle, he refused to
leave his medical post and was captured.
Soon released to care for wounded soldiers,
he was almost immediately captured again.
(Courtesy of the Burton Collection, Detroit
Public Library.)

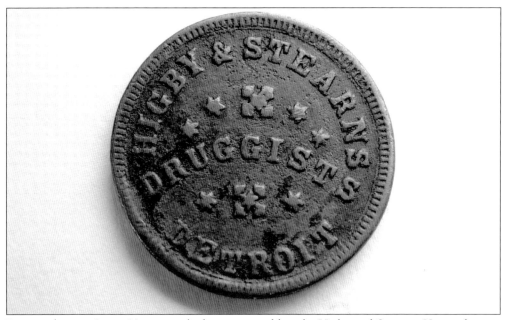

Prior to the war, James Vernor worked as an errand boy for Higby and Stearns. He was known for his meticulous attention to detail even as a teenager. His skill at packaging goods quickly earned his promotion to junior clerk. On August 14, 1862, at age 19, he enlisted to serve in the Civil War.

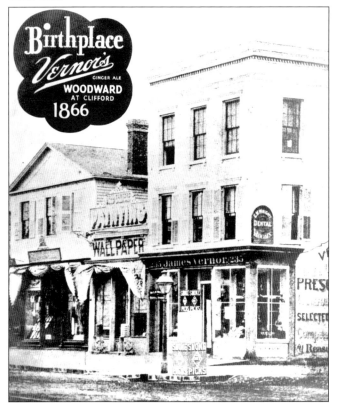

The most famous story of the origin of Vernor's Ginger Ale has young James Vernor experimenting with ginger ale extract prior to the Civil War. All his experiments produced a ginger ale that was much too strong. He stored away one of his extract casks before enlisting. Upon his return, Vernor opened a drugstore at 235 Woodward Avenue in Detroit. He also opened his stored cask and discovered the four years had mellowed the taste to perfection. (Vernor's is a registered trademark of A&W Concentrate Company. All rights reserved.)

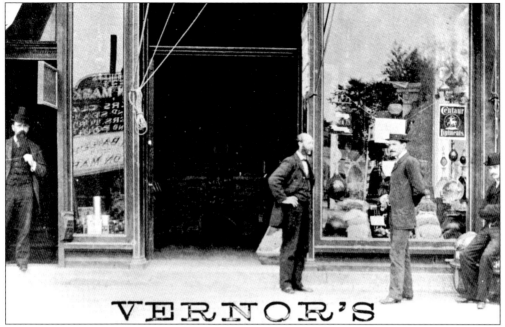

Another sequence of events is more likely. Vernor was an entrepreneur. He not only sold pharmaceuticals, he sold flowers, perfumes, and other goods. His store was so far north of the city center, way up by Clifford Street, he needed to attract customers. So he opened a soda fountain within his drugstore. It was then he began experimenting with ginger ale extracts. Vernor's Ginger Ale still originated in 1866 but probably was not perfected until about 1870. (Courtesy of Superior View.)

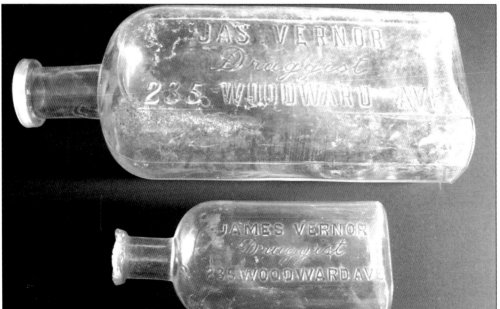

For 30 years, from 1866 to 1896, James Vernor was a pharmacist. His store was located at the southwest corner of Woodward Avenue and Clifford Street in Detroit. This photograph shows two sizes of medicine bottles. They are embossed "James Vernor Druggist 235 Woodward Ave."

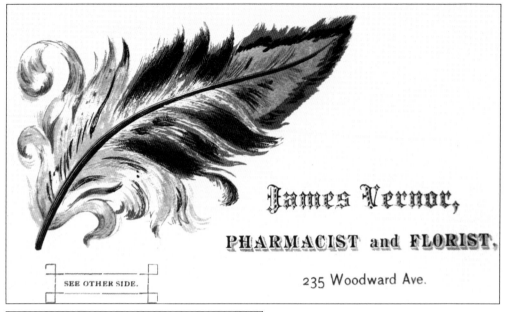

James Vernor,

PHARMACIST and FLORIST,

SEE OTHER SIDE.

235 Woodward Ave.

VERNOR'S PHARMACY,
235 Woodward Avenue,
DETROIT.

MADAME:

It is the design of this card to call your attention more particularly to the

Floral Department

which I have recently added to my business. It is my intention to keep constantly on hand small baskets and bouquets of choice natural Flowers, tastefully arranged, and to

──MAKE TO ORDER──

more elaborate work of every description, Table Designs, Bouquets, Presentation Baskets, Funeral Emblems, &c.

You are cordially invited to examine our display of Flowers at any and all times it may be convenient to you to do so, and should you at any time require anything in the Floral line, your orders are respectfully solicited.

JAMES VERNOR.

HISTON, CARD MFR., PHILA.

The front and back of a rare James Vernor, pharmacist and florist, card are pictured. From 1866 to 1896, Vernor operated his drugstore. A 1932 publication, *Pharmaceutical Era*, reported that sales of Vernor's Ginger Ale "went from $800 in 1870 to $10,000 in 1872." That is a substantial amount of money in 1872. Yet a newspaper article from 1888 still referred to Vernor as a druggist and florist, never mentioning his ginger ale business. Vernor was also active in the City of Detroit government, serving as an alderman.

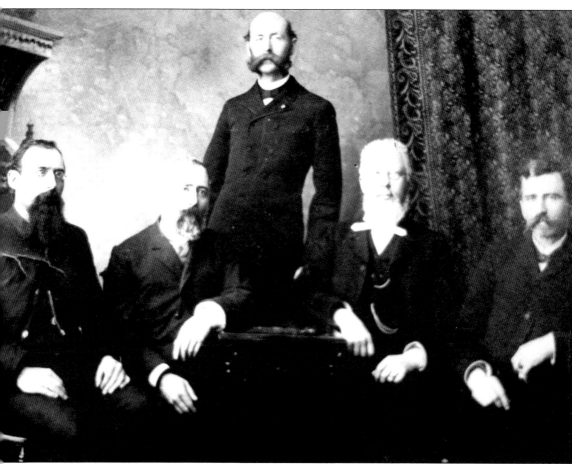

James Vernor was a perfectionist. Everything he did, he did well. He was concerned about the quality of drugs and medicines. He led a movement to create standards and certification. He held State of Michigan Board of Pharmacy license No. 1 all the years of his practice. This photograph is the original Michigan Board of Pharmacy, formed in 1887. The photograph shows, from left to right, Ottmar Eberbach, Ann Arbor; George McDonald, Kalamazoo; James Vernor, Detroit; Stanley Parkill, Owosso; and Jacob Jesson, Muskegon.

COMPLIMENTS OF

JAMES VERNOR, FLORIST,

235 Woodward Avenue.

Very little written information exists on when James Vernor added flowers to his business. It is known that he did not begin his business selling flowers. Company literature states he was so far north that many people thought his business would fail. Flowers may have been added as an additional way to make sales. He purchased his flowers from two greenhouses in Detroit. On two occasions, he traveled to Cincinnati to judge flower shows. The front and back of a rare James Vernor, florist, card are pictured.

CUT
FLOWERS

Receiving our supply fresh from the growers each morning we are prepared to execute orders for floral work on the shortest notice.

Orders received by Telephone, Mail or Telegraph will receive especial attention.

JAMES VERNOR,

FLORIST,

235 Woodward Ave., DETROIT.

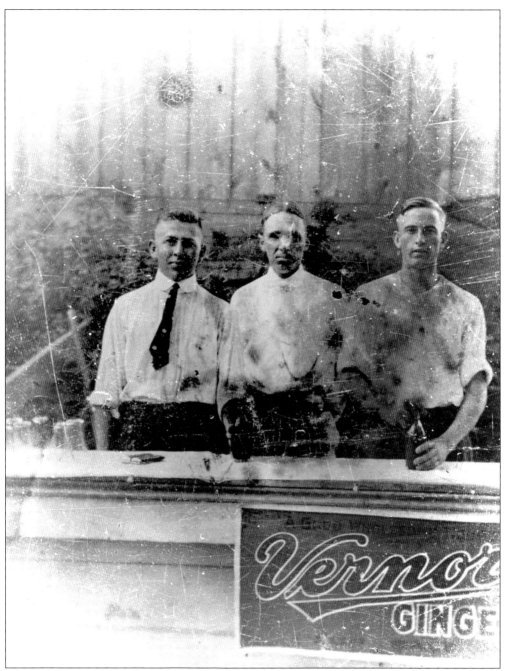

By 1896, bottling technology had improved enough to allow a highly carbonated soda to be bottled, capped, and taken home. Prior to that, the only way to enjoy a soda was to go to a fountain and have it specially made. The three men shown above, in an early tintype photograph, may have been called soda jerks. This was not an insulting term but referred to a skill necessary to correctly jerk the fountain handle to add the soda water to mix with the flavored syrup.

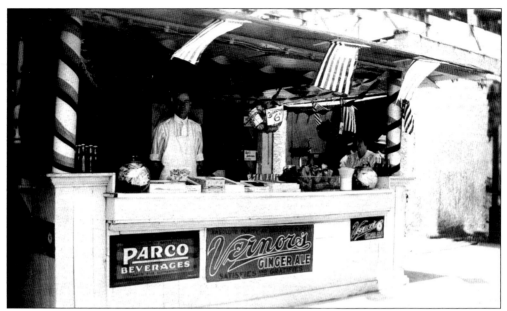

Vernor's was available in many places across the city. Stands like the one shown above were often stocked with Vernor's Ginger Ale. A variety of advertising signs helped attract customers and let them know what was available at the stand. The location of the stands in these two photographs is unknown. But seeing a roller coaster in the background, it could have been Bob-lo Island, Edgewater Park, Walled Lake Amusement Park, or some other fair or carnival. (Courtesy of Mike Novak.)

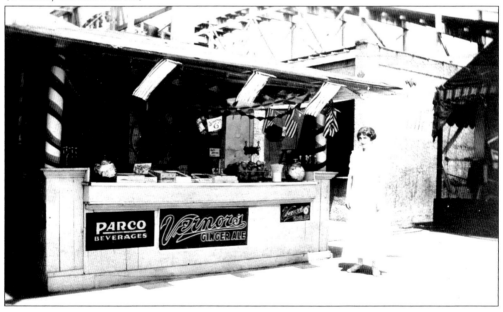

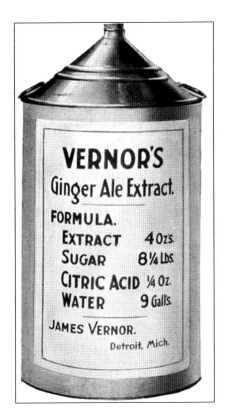

James Vernor sold extract to other soda fountain owners across the United States. He also supplied schools and hospitals. He had exacting standards for how Vernor's Ginger Ale should be made and the temperature at which it should be served. Vernor also had his own carbonated seltzer water with which to mix it. Vernor's Ginger Ale was to be served at 36 degrees, and consumers were instructed not to dilute it with ice.

SEASON OF 1890.

PLATT & COLT,

DRUG-SELLERS,

No. 78 East State Street, Ithaca,

SERVE THE COOLEST, PUREST AND MOST DELICIOUS

SUMMER BEVERAGES.

The most scrupulous care given to every detail.

M · E · N · U

MILK SHAKE, (5c.)

Lemon, Strawberry, Vanilla, Pineapple,
Chocolate, Nectar, Orange, Coffee, Maple.

ICE CREAM MILK SHAKE, (10c.)

Lemon, Strawberry, Vanilla, Pineapple, Chocolate,
Nectar, Orange, Coffee, Maple.

SODA WATER, (5c.)

Sarsaparilla, Strawberry, Chocolate, Vanilla, Pineapple,
Nectar, Orange, Coffee, Maple, Lemon.

ICE CREAM SODA WATER, (10c.)

Sarsaparilla, Strawberry, Chocolate, Vanilla, Pineapple,
Nectar, Orange, Coffee, Maple, Lemon.

SHERBETS, (5c.)

Mexican, Orange, Lemon, Pineapple, Catawba Grape Juice.

ICE CREAM SHERBETS, (10c.)

Mexican, Orange, Lemon, Pineapple, Catawba Grape Juice.

MISCELLANEOUS DRINKS, (5c.)

Lemon Phosphate, Orange Phosphate, Rock Candy Lemonade,
Boston Birch Beer, Bowker's Root Beer, Frui Miz, Malto, Red Messina Orange,
Lemon Sour, Vernor's Ginger Ale, Excelsior Saratoga Water.

EGG DRINKS, (10c.)

Egg Phosphate, Egg Lemonade, Egg Milk Shake, with all flavors.

ICE CREAM, STRAIGHT, (15c.)

We will serve your drink EXTRA SWEET or EXTRA SOUR if so ordered. Platt & Colt's Store is open at all hours.

Evidence of Vernor's early expansion across the United States is found in this "Season of 1890" menu from Platt and Colt in Ithaca, New York. Noted under miscellaneous drinks is Vernor's Ginger Ale, for just 5¢. Platt and Colt was not a restaurant but another drugstore with a soda fountain.

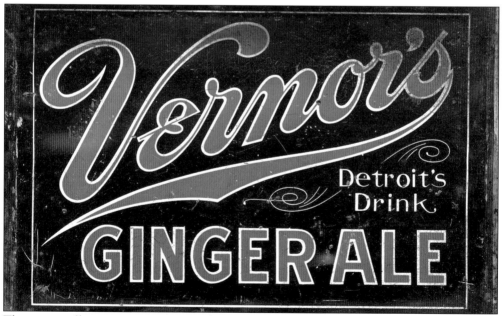

This very small countertop sign was made to remind customers to buy a Vernor's instead of some other soda when they came to the fountain. The sign also reminded customers that Vernor's was "Detroit's Drink." Vernor's had not yet chosen the familiar green and yellow colors for the brand. The colors of this sign are black and red. (Vernor's is a registered trademark of A&W Concentrate Company. All rights reserved.)

18

This postcard of a little girl and her dog is, unfortunately, not dated. However, the era must be around 1900. Behind her a Vernor's sign that is apparently made out of fabric is visible. The Vernor's slogan of the era appears on the sign: "a good, wholesome, nourishing drink." This postcard was not intended to be a Vernor's advertisement. The girl just happened to be standing in front of a Vernor's sign when the photograph was taken.

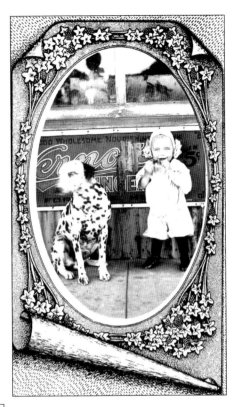

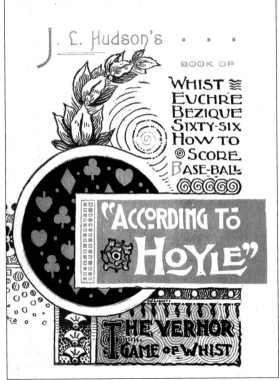

Detroit's movers and shakers must have socialized together during the late 1800s. Here a publication from the J. L. Hudson Company includes James Vernor's version of the card game Whist. The game is played with 36 decks of cards, and each player plays four hands. The publication is dated 1889.

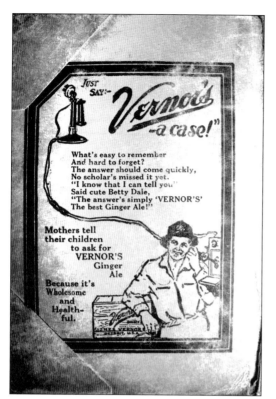

A book cover from 1917 depicts the Vernor's delivery boy on the telephone waiting for an order. Schoolchildren using this book cover are reminded that "Mothers tell their children to ask for Vernor's Ginger Ale because it's wholesome and healthful."

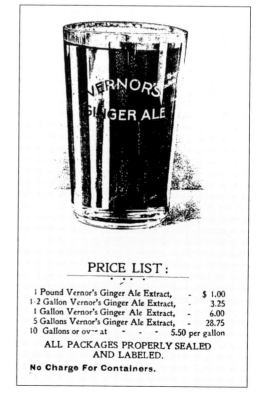

PRICE LIST:

1 Pound Vernor's Ginger Ale Extract,	$ 1.00
1-2 Gallon Vernor's Ginger Ale Extract,	3.25
1 Gallon Vernor's Ginger Ale Extract,	6.00
5 Gallons Vernor's Ginger Ale Extract,	28.75
10 Gallons or ov-- at - - -	5.50 per gallon

ALL PACKAGES PROPERLY SEALED
AND LABELED.

No Charge For Containers.

Inside this early price list, James Vernor shows his entrepreneurial side as he explains how much money can be made by purchasing his extract and selling it to customers. Pricing ranges from $1 for one pound of extract to $28.75 for five gallons of extract.

In 1896, Vernor closed the drugstore and moved to a location closer to the Detroit River. James Vernor II joined his dad to concentrate on the ginger ale business full-time. At that same time, bottling technology improved so that a highly carbonated beverage could be bottled without the bottle exploding. Two Vernor's bottles from around 1900 are pictured here. The glass is embossed with the Vernor's Ginger Ale VGA logo in the center. The earliest of the bottles had a ceramic cork wired onto the bottle. Later Vernor went to a cork-lined metal crown cap.

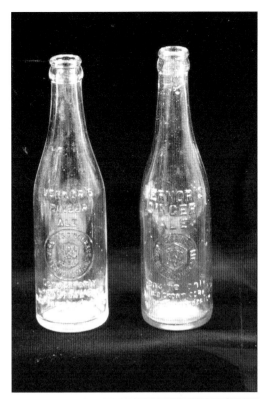

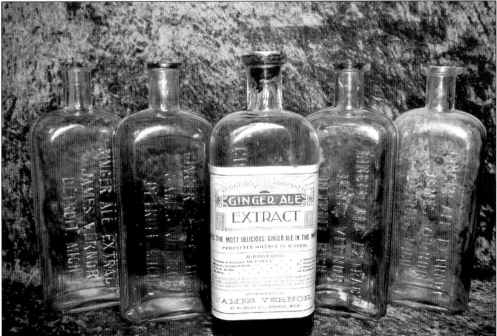

Vernor grew the business through sales of the extract. Quite a bit of his sales energy was devoted not to retail but to extract sales to hundreds of soda fountains across Detroit and beyond. His literature stated how little extract was needed to make large profits.

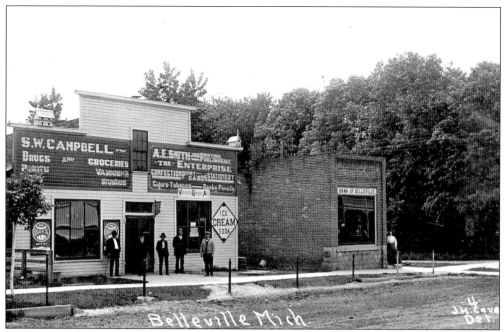

James Vernor began expanding his ginger ale enterprise almost immediately. His sales of extract to other proprietors had been one of the keys to his success. With the ability to distribute Vernor's in bottles, it opened up new sales opportunities. This 1910 postcard of Belleville shows an early Vernor's Ginger Ale sign attached to a market.

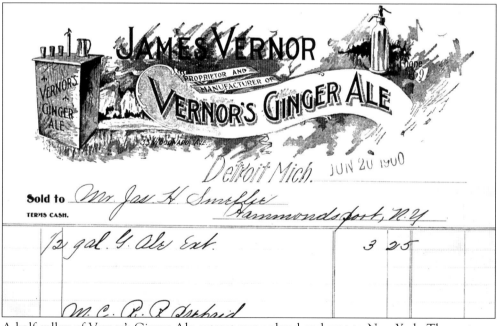

A half gallon of Vernor's Ginger Ale extract was ordered and sent to New York. The cost was $3.25. The letterhead shows the address in June 1900 was 33 Woodward Avenue. The receipt shows the telephone number as just three digits—169.

This beautiful old tin countertop sign is from approximately 1918. The advertising line "Detroit's Drink" was used during that time period and was embossed right onto bottles of Vernor's. The label on the bottle is the earliest paper label design for Vernor's. (Vernor's is a registered trademark of A&W Concentrate Company. All rights reserved.)

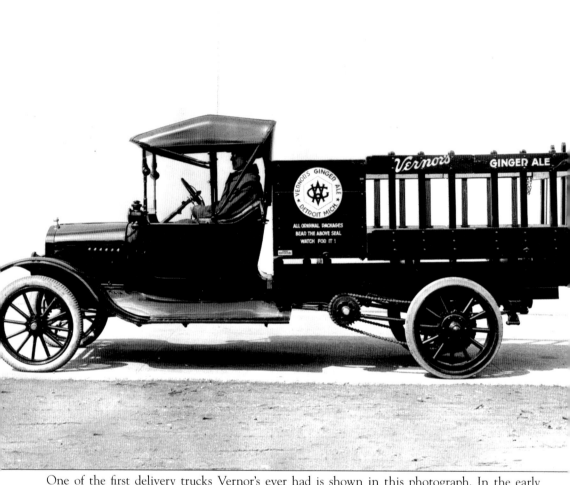

One of the first delivery trucks Vernor's ever had is shown in this photograph. In the early years, Vernor's used a horse and carriage to deliver extract throughout Detroit. One of the two James Vernors would drive the carriage. As the distribution territory expanded, the use of trucks became a necessity. (Courtesy of the Manning Brothers Historic Photographic Collection.)

Two

FACTORIES AND FOUNTAINS

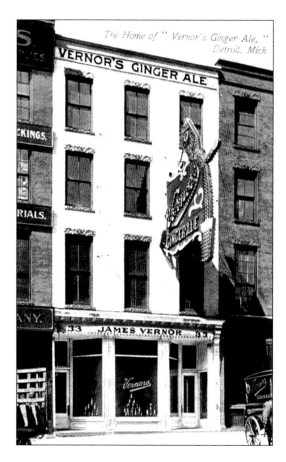

The year 1896 was an important year for
James Vernor. His son, James Vernor II,
entered the company. He also decided
to close his pharmacy and concentrate
solely on the production and distribution
of Vernor's Ginger Ale. The store at
235 Woodward Avenue was closed, and a
new one opened at 33 Woodward Avenue.
No longer could he be criticized for being
too far north. His new location was south
of Jefferson Avenue, very close to the
Detroit River.

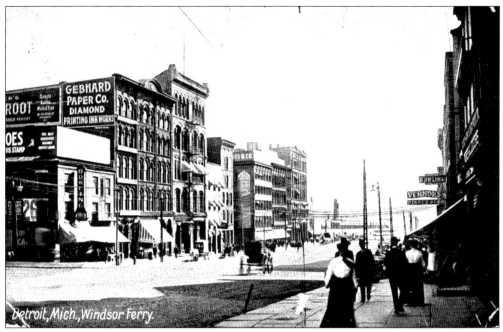

These two early postcards show the location of Vernor's relative to the Detroit River. Note the Vernor's sign on the right in the postcard above and on the left in the postcard below, looking south and north, respectively, on Woodward Avenue. The street number, 33 Woodward Avenue, would change in the 1920s. The new number, 239 Woodward Avenue, was the exact same building. However, the street renumbering has often caused confusion due to the similarity with the pharmacy location of 235 Woodward Avenue. The location of the original James Vernor pharmacy was many blocks north of the second location.

This old and tattered menu features Vernor's Ginger Ale at the bottom. James Vernor knew he could not sustain his soda pop business with just one fountain at the foot of Woodward Avenue. His extract was available for other soda fountains. When purchasing his extract, his serving directions had to be followed exactly. One brochure states, "Not a single glass should ever be sold at a temperature above 45 degrees."

FOUNTAIN SPECIALS

SODAS

JUMBO DOUBLE DIP

Chocolate	Coffee
Pineapple	Cherry
Fresh Lemon	Lime
Strawberry	Vanilla
Root Beer	Orange

Chocolate Mint

Fresh Fruits in Season

❖ ❖ ❖

"Frosty Features"

Cooling — Refreshing — Thirst Quenching Temptations. Made with plenty of ice, the tasty sparkling flavor of pure fruit juices.

Fresh Lemonade	.10
Fresh Limeade	.10
Fresh Orangeade	.10

Served with plain or zeltzer water

With Fruits	.15
Freezes	.15
Grape Juice	.10
Frosted Malted	.10
Black Cow	.10

SUNDAES

Chocolate	Cherry
Pineapple	Strawberry
Marshmallow	Butterscotch
Frozen Fudge	Butter Pecan

Chopped Nut Sundaes 3c more

Whole Mixed Nut Sundae
5c more

FANCY SUNDAES

Choice Giant Pecan	.25
Banana Split	.25

3 flavors Ice Cream with fruits, nuts, whole banana and whipped cream.

Pecan Nest	

3 flavors Ice Cream with Chocolate, Marshmallow, crushed Cherry, whipped cream and nested in Pecans.

Cherry Parfait	.20
Chocolate Parfait	.20
Fudge Nut	.20

VERNOR'S
GINGER ALE

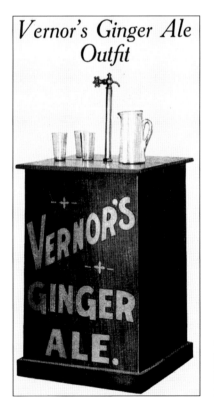

Vernor's Ginger Ale Outfit

James Vernor did not just sell extract to soda fountains, he sold the apparatus for serving Vernor's as well. This brochure contains the set up instructions in addition to the proper mixing and pouring of Vernor's Ginger Ale.

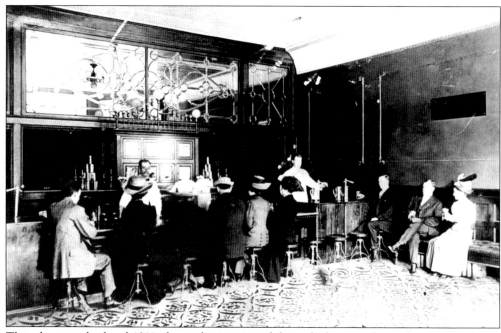

This photograph, dated 1914, shows the interior of the soda fountain located at 33 Woodward Avenue. James Vernor must have been pleased with the number of customers his soda fountain attracted. As the clothing indicates, it was a nice evening out to go enjoy a glass of Vernor's.

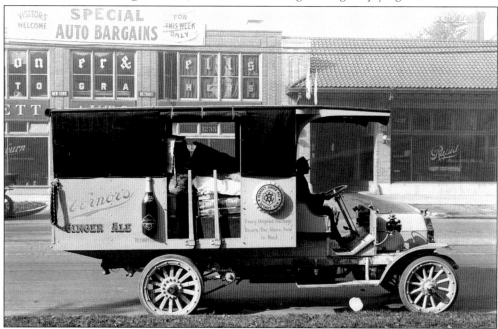

When James Vernor II entered the business, the company had three workers: James Vernor, James Vernor II, and a horse named Dick. The three of them took care of every aspect of the ginger ale business. They washed the bottles; bottled the pop; delivered to homes, schools, and hospitals; and took care of the store. The horse-and-wagon delivery method was replaced by trucks. This 1917 delivery vehicle was put into service to speed distribution. (Courtesy of Mike Novak.)

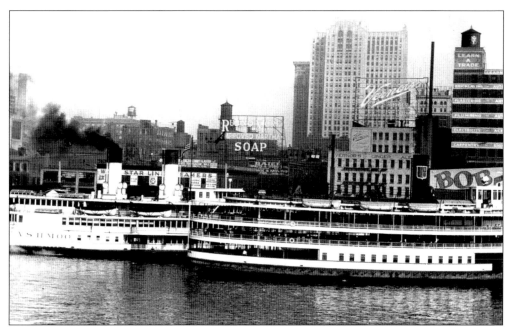

The boats *Tashmoo* and *Ste. Claire* are docked by the huge illuminated Vernor's Ginger Ale sign on the Detroit River. Interesting advertisements for "improved naptha soap" and "toothache wax" join the Vernor's illuminated sign on the riverfront. The year is approximately 1920. (Courtesy of Superior View.)

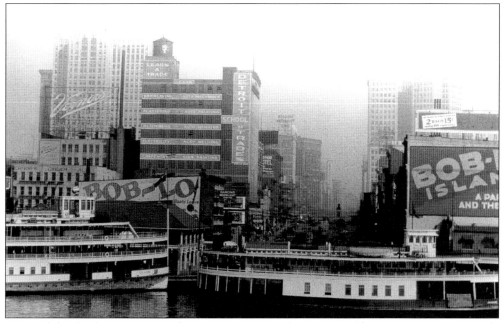

Some of the fondest memories of Vernor's was going downtown and stopping at Vernor's soda fountain before getting on the Bob-lo boats. Customers might order a Vernor's, or a cream-ale, a Boston Cooler, or even chocolate Vernor's. The Detroit School of Trades would soon become part of the Vernor's plant. Looking up Woodward Avenue, streetcars and a station for a police officer to direct traffic are visible. (Courtesy of Superior View.)

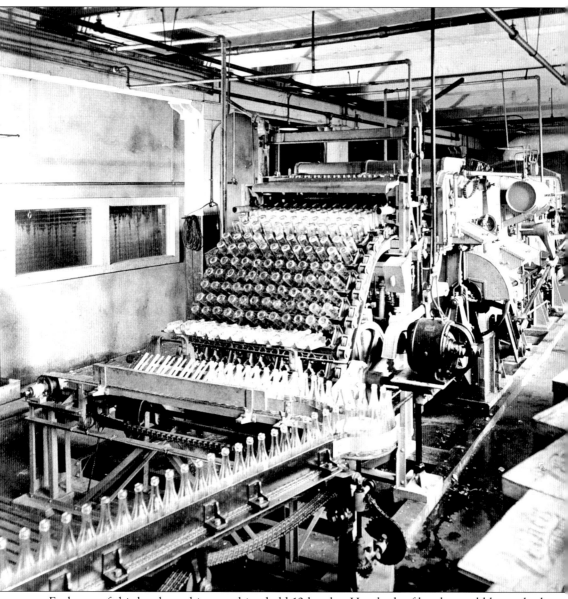

Each row of this bottle-washing machine held 12 bottles. Hundreds of bottles could be washed simultaneously inside. Once clean and sterile, bottles exited the machine and moved down a conveyor to begin the bottling process.

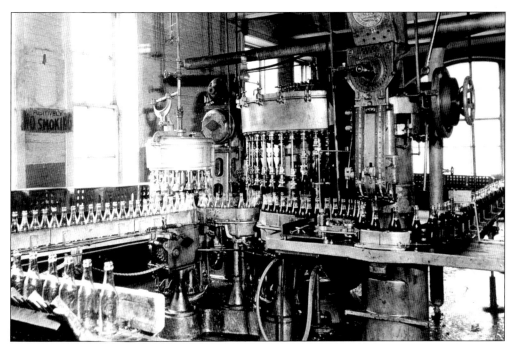

Embossed bottles from the early 1900s travel along a conveyor on their way to a machine that fills them. Along the windows, empty cases waiting to be filled are visible. Due to cork being part of the capping mechanism, these early bottles were placed upside down in their cases. This kept the cork wet and the carbonation inside.

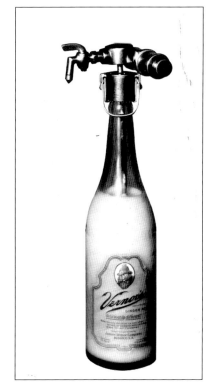

This is a close-up image of a bottle being filled. The paper gnome label dates from the 1930s. The mechanism on top is meant to keep all that famous carbonation inside the bottle where it belongs. The image must have been taken to illustrate the bottling process to prospective franchisees.

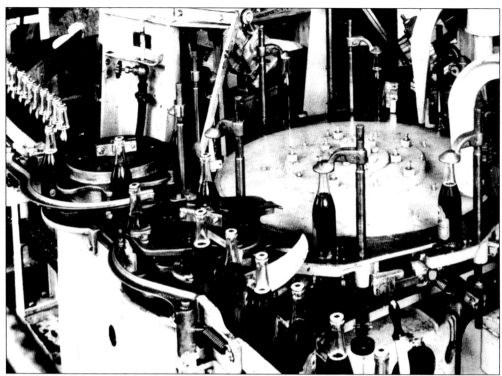

One of the final steps along the bottling route was applying a label to the bottles. This early photograph shows bottles entering the machine capped but with no labels. As they travel clockwise through the machine, a paper label is applied. These labels feature the delivery boy logo.

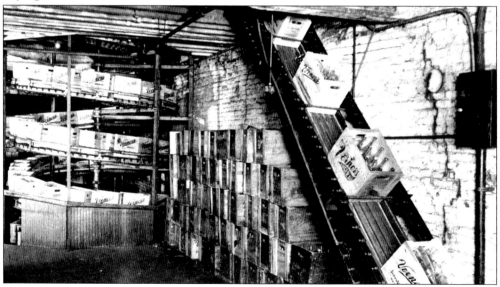

James Vernor used gravity to move filled cases through the 10-story plant. The ingenious idea not only saved utility costs, it produced an efficient process for moving ginger ale through the plant. Cases moving down a circular set of rollers, using no electricity at all, can be seen in this photograph.

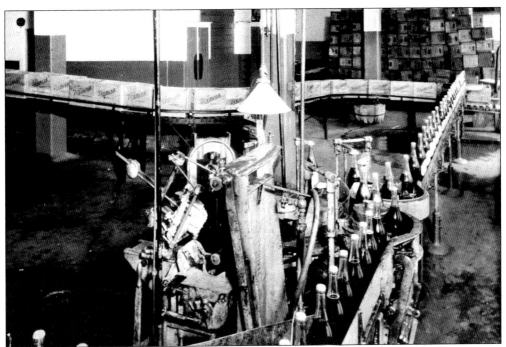

Filled and capped bottles head down one conveyor through a machine that applied a Vernor's label. Empty cases are filled and moved along another conveyor so they can be loaded on trucks.

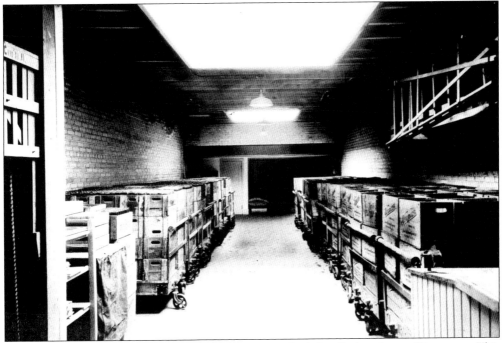

Empty cases are to the right, and filled cases are to the left, all placed on rolling carts. This distribution area took in empties from deliveries and then filled the trucks with cases of Vernor's. One early loading method removed the entire back carriage of the delivery truck and immediately replaced it with a fully loaded one.

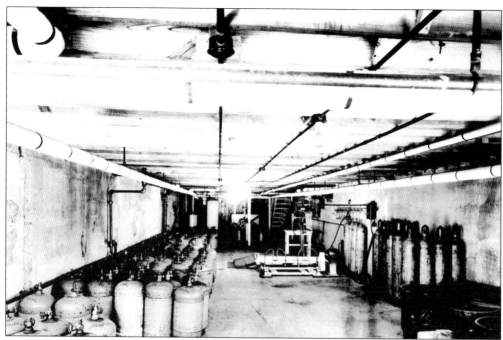

In addition to ginger ale extract, Vernor's also produced its own carbonated water. Shown here are tanks of carbonated water waiting for use in the basement of the factory. As with everything he did, the sterility of the water was of great importance. Early magazine articles note the multistep processes James Vernor used to purify his water.

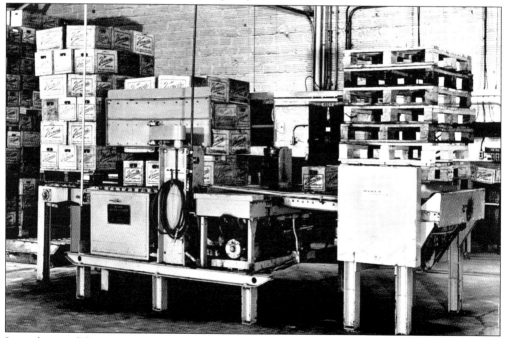

In order to deliver cases of bottles out to stores and distribution centers, this machine was used. Each pallet was loaded with cases, and they were secured as one unit with this palletizing machine.

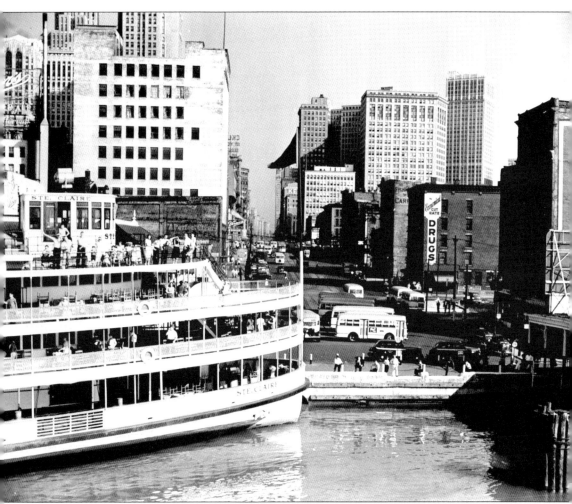

One of the Bob-lo boats, the *Ste. Claire*, is docked just south of the Vernor's plant and soda fountain. Just behind the *Ste. Claire* is a 10-story building that Vernor's purchased and would be incorporating in its facility. The sign over the entrance to the original building can be seen looking north up Woodward Avenue. (Courtesy of Superior View.)

This photograph shows the exterior of one of the Vernor buildings. Bronze plaques saying "Vernor's Ginger Ale—Detroit's Drink" were placed in many places around the outside. This was also the 80th anniversary year, as can be seen in the 1866–1946 sign attached to the building.

Vernor's Ginger Ale bronze plaques and carved Vs in the stonework adorn one of the buildings in the Vernor's block. The windows have been painted, most likely due to World War II efforts to dim the bright lights of cities.

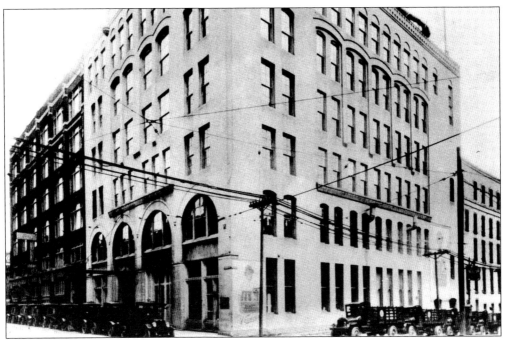

Everything James Vernor did was done with detail and precision. He devised a system by which truck beds were loaded within the factory and dropped onto the chassis waiting outside the factory. Trucks are lined up outside the factory. The original delivery boy logo is painted on the corner of the building.

Cars park in front of the entrance to the Vernor's soda fountain. Streetcars may have been an even more common way customers traveled for their favorite Boston Cooler. Whatever the mode of transportation, Vernor's was a destination any night of the week. Adjacent to Vernor's, Mariner's Church sits in its original location. Notice the sign has been modified by removing the glass and the words *ginger ale*. (Courtesy of Superior View.)

One of the many Vernor's signs with the lightbulbs in the glass that make it appear to fill up is being removed. The reason is not clear, but it could have been part of the darkening of major cities during World War II. It could also have been for a logo change at the plant. The photograph on the previous page shows the sign without these two pieces.

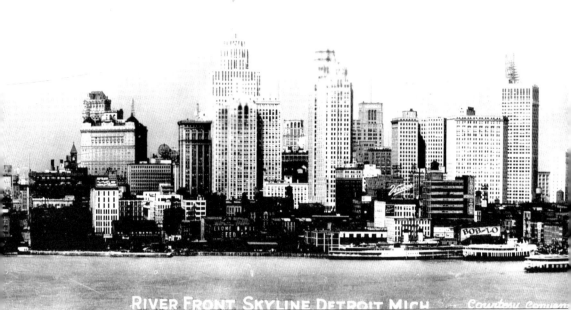

RIVER FRONT SKYLINE DETROIT MICH — *Courtesy Conway*

The Vernor's sign is prominent in the skyline of Detroit. The Bob-lo boats are docked, and the once mighty Hudson's Department Store is visible in the background. The city has grown and is one of the top 10 largest cities in the United States.

Dispenser, Model 21

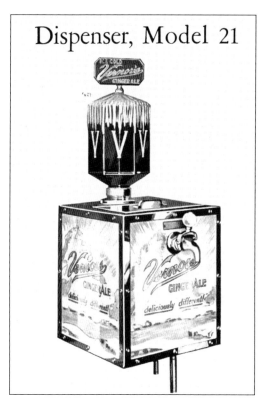

The James Vernor Company produced some wonderful soda dispensers over the years. These two images are from a 1928 brochure on dispensing equipment. Vernor wanted retailers to have a dispenser that was a showpiece for their counter. These two are fine examples of the high-quality dispensers he sold or leased to store owners. Each dispenser includes a wonderful glass piece with embossed ice and etched Vs for *Vernor*'s. (Vernor's is a registered trademark of A&W Concentrate Company. All rights reserved.)

Dispenser, Model 41c

"Counter Arm Type"

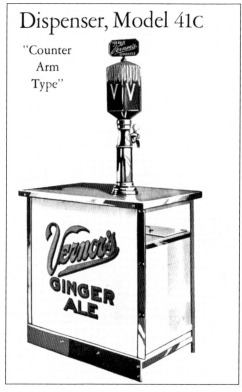

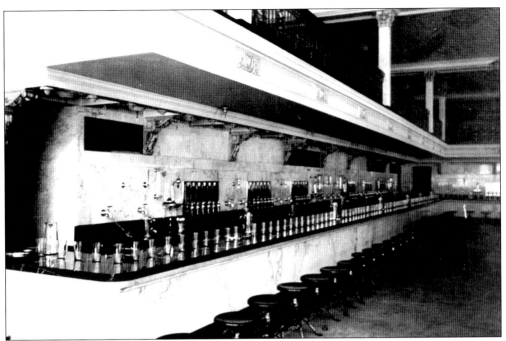

The huge marble counter was one of the favorite places to be inside the store. Customers purchased a ticket at the cashier's window and took it to the fountain to choose their drink. The rare part about this image is that the soda fountain is empty. It was usually packed with people.

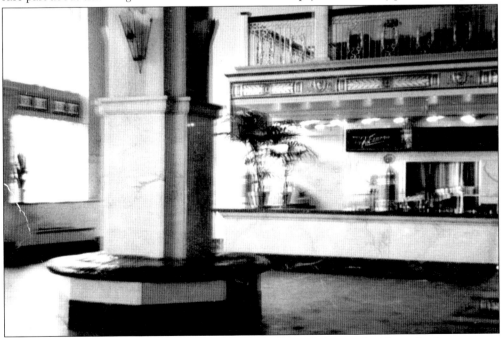

The soda fountain itself was located in the 239 Woodward Avenue building. As the company grew, the location expanded to include many other adjacent buildings. The stools and light fixtures in the soda fountain changed over the years, but the huge marble countertop remained the same.

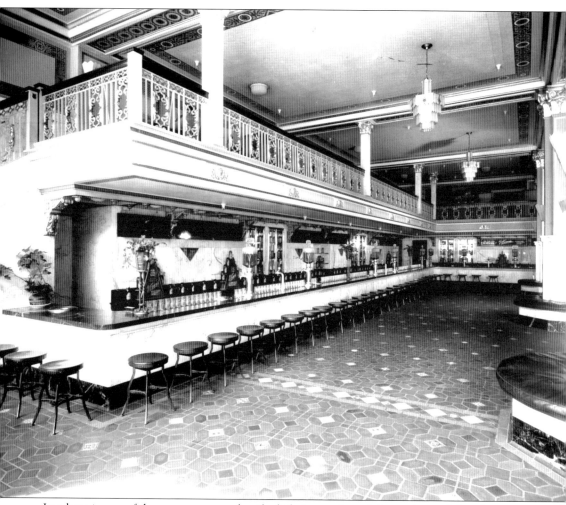

In a later image of the same counter, the tile, lighting, and stools have changed, but the massive soda fountain counter remains. Thirty-two stools are visible along with eight etched-glass Vernor's dispensers. It is no wonder this incredible soda fountain is a favorite memory of many Detroiters. (Courtesy of the Manning Brothers Historic Photographic Collection.)

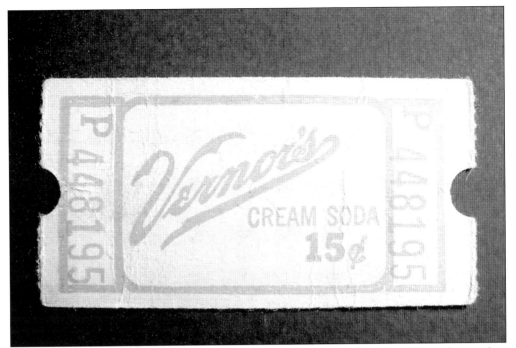

One example of a Vernor's ticket is pictured above. During the 1940s, one could purchase a glass of Vernor's for 5¢. For 15¢, one could treat a date or purchase a more exotic recipe that cost more money.

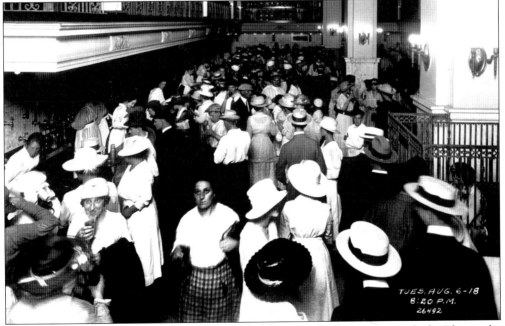

This photograph is dated August 6, 1918. The Vernor's soda fountain is packed with people. Quite a crowd for a Tuesday night! Eleven women are visible serving Vernor's from behind the counter to meet the demand. The soda fountain was always a popular place to go for a night out. (Courtesy of the Manning Brothers Historic Photographic Collection.)

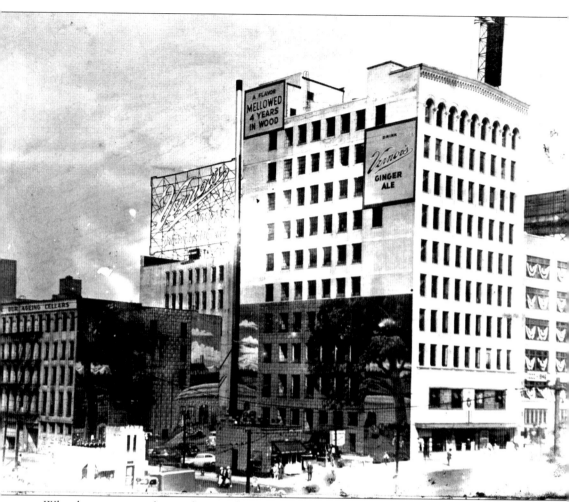

What began as a single storefront at the foot of Woodward Avenue became an entire city block. In 1918, the old Riverside Power Plant was purchased and added to the bottling plant. In 1919, a six-story building was built next to it. In 1941, an additional 10-story building was purchased, and the Vernor's plant was considered the "most modern bottling facility in the world." (Vernor's is a registered trademark of A&W Concentrate Company. All rights reserved.)

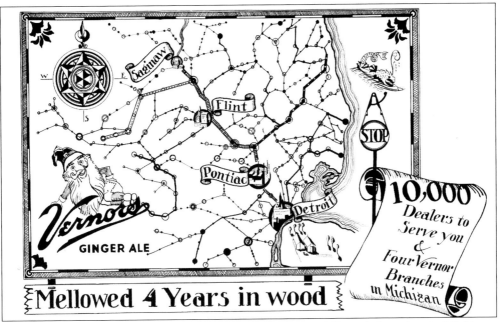

The gnome relaxes on the Vernor's logo in this 1929 map of Vernor's locations in Michigan. Vernor's Ginger Ale could be purchased at an impressive 10,000 locations. The Detroit, Pontiac, Flint, and Saginaw branches would grow to include many more in Michigan, the United States, and Canada.

This Vernor's soda fountain was located on Saginaw Street in downtown Pontiac. It features one of the electronic signs with the glass that fills as the bottle empties. This photograph was taken in the mid-1940s. The building still exists today but has seen many different businesses since its days as a Vernor's soda fountain.

The Vernor's soda fountain in Flint also featured a large mural with gnomes, similar to the Detroit plant. This 1929 photograph shows the original version of the mural. Both the soda fountain building and the mural still exist today, although the soda fountain is now a Halo Burger restaurant. (Copyright 1929 the Flint Journal. All rights reserved. Used with permission of the Flint Journal.)

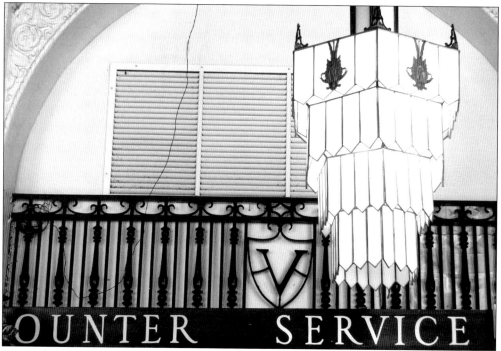

Ornate lighting and wrought iron adorn the interior of Vernor's Flint soda fountain. Notice the V in the ironwork that runs across the second floor. The plaster was also very detailed. In later years, the building was expanded to meet the growing demand of customers.

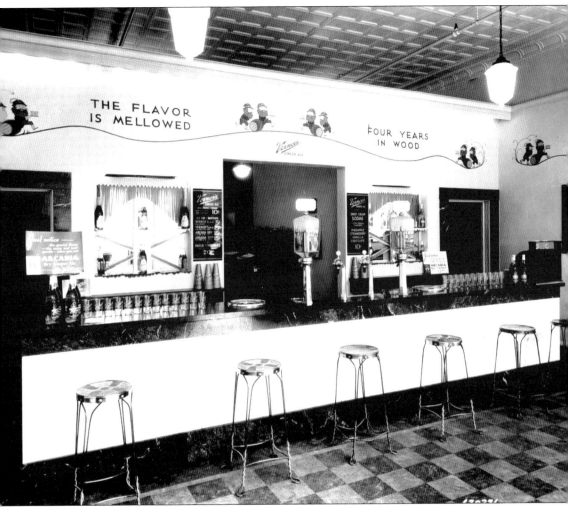

The Toledo, Ohio, Vernor's soda fountain may only have had six customer stools at the counter, but it sold Arcadia Dry Ginger Ale. James Vernor I was totally against alcohol. After his death in 1927, James Vernor II added the Arcadia line as mixers. This photograph, from the early 1930s, also shows the famous megaphone serving cups and etched-glass fountain dispensers. (Courtesy of the Manning Brothers Historic Photographic Collection.)

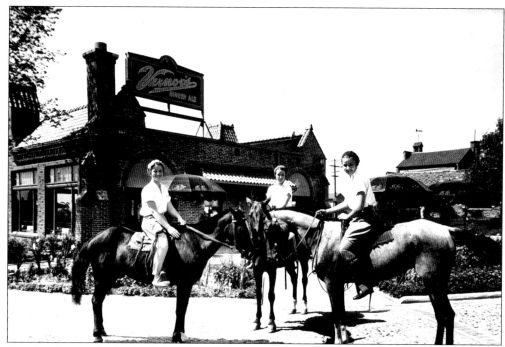

Handwriting on the back of this photograph says these three girls skipped school to ride their horses to the Dayton, Ohio, Vernor's soda fountain. Both inside and out, the Dayton branch was one of the most beautiful branches Vernor's ever built.

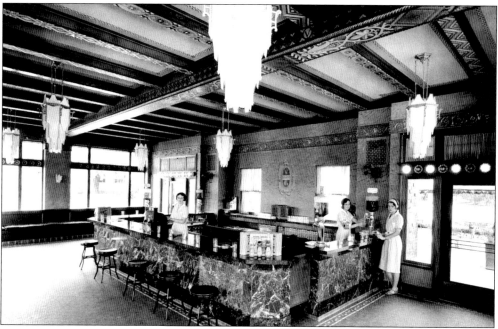

The beautiful interior of the Dayton, Ohio, Vernor's soda fountain is shown in this photograph. Note the Vs in the ornate plaster ceiling and four etched-glass Vernor's dispensers. Whether arriving on horseback, bicycle, or automobile, the Dayton branch was a real treat. (Courtesy of the Manning Brothers Historic Photographic Collection)

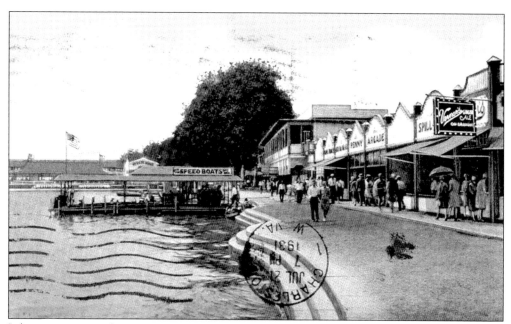

It became more and more common to find a Vernor's soda fountain in cities across the United States. This Buckeye Lake postcard, complete with 1931 postmark on the front of the postcard, is just one more example of all the places a Vernor's store could be found. The sign on the store says, "Vernor's Ginger Ale on draught."

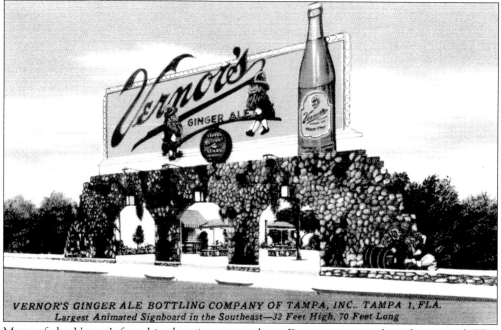

VERNOR'S GINGER ALE BOTTLING COMPANY OF TAMPA, INC.. TAMPA 1, FLA.
Largest Animated Signboard in the Southeast—32 Feet High, 70 Feet Long

Many of the Vernor's franchise locations were places Detroiters went when they retired. This postcard shows the Tampa, Florida, plant and soda fountain. At the time, the sign was noted as one of the largest illuminated signs in the country: 32 feet high by 70 feet long. A narrative on the back of the postcard invites customers to enjoy the Cabana Club and sit under the beautiful palm trees while enjoying a glass of Vernor's.

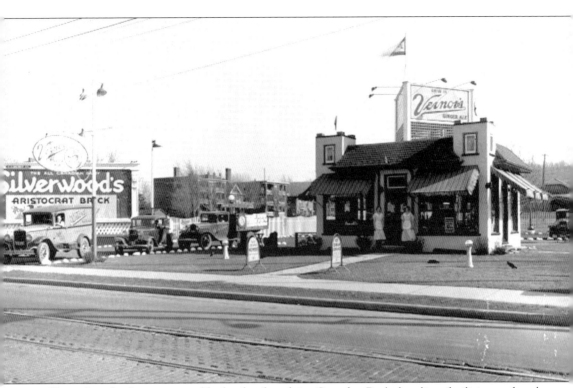

Vernor's soda fountains could also be found in Canada. Both bottling facilities and soda fountains could be found on the other side of the Detroit River. This image from the 1930s features a Canadian Vernor's outlet. Three Vernor's vehicles are ready in the driveway as two Vernor's Girls stand by the front door. Streetcars traveled right in front of this location. Nearby is another favorite memory for Canadians: a Silverwood's Dairy billboard.

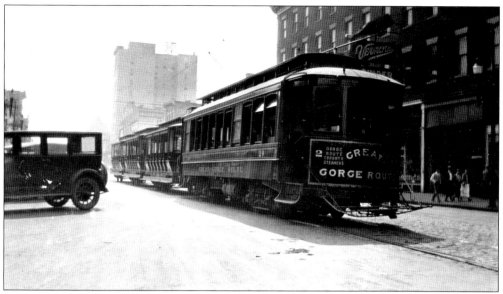

The Great Gorge Route trolleys ran around the Niagara Gorge at Niagara Falls, New York. The trolley passes the Niagara Falls Vernor's soda fountain in this 1921 photograph. Note the Vernor's sign is the same as those found on other Vernor's soda fountains of this era.

Businesses across the United States and Canada picked up Vernor's in their restaurants and soda fountains. Herman's, located on East Queen Street in Toronto, Ontario, was one such location.

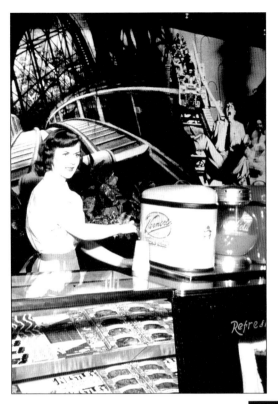

This promotional photograph shows prospective customers how nice it is to have a Vernor's dispenser at their theater candy counter. The photographer appropriately tried to eliminate the Coke machine from the picture.

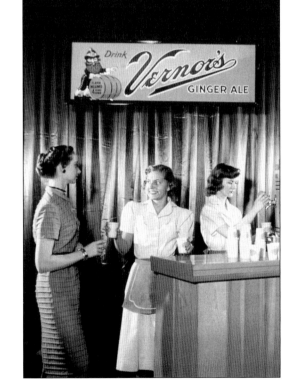

In another promotional photograph, two Vernor's Girls serve Vernor's to a customer. Barely in the photograph is a beautiful porcelain cylinder dispenser. A large Vernor's sign with the gnome hangs from above.

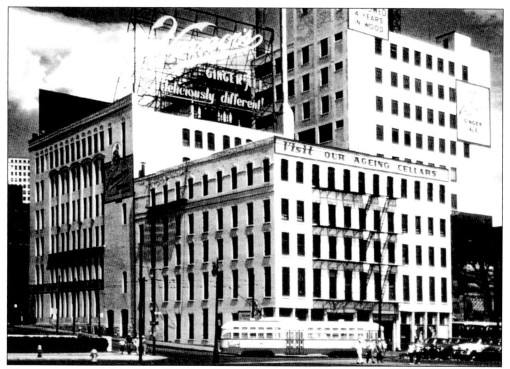

The immense size of the Vernor's plant can be seen in this photograph. It took up an entire city block. The streetcars turned around at Vernor's and headed back north up Woodward Avenue. This image is dated 1954, nearing the end of the streetcar era in Detroit.

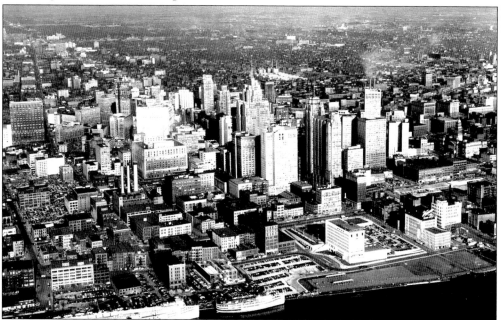

In the lower right corner of this aerial photograph, the Vernor's block, with the huge illuminated sign, is prominent on the Detroit riverfront. The downtown area has grown considerably. Huge cruise ships line the waterfront, and streetcars are visible in the bustling city below.

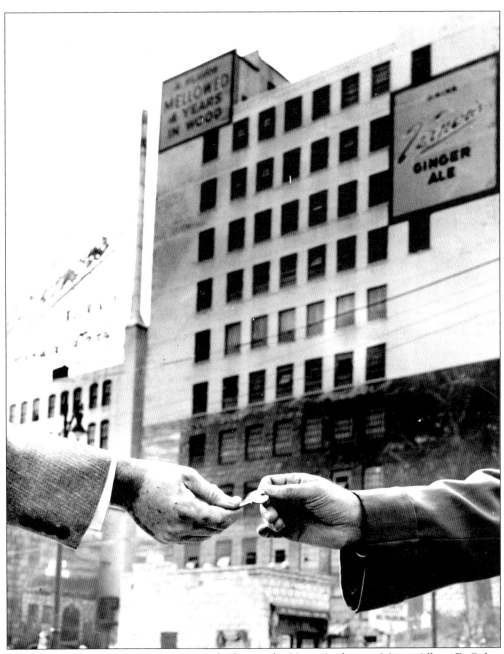

The hand of J. Vernor Davis, left, gives the key to the Vernor's plant to Mayor Albert E. Cobo, right. The City of Detroit asked Vernor's to leave its property on the river so a new exhibition center (Cobo Hall) and promenade could be built. The city gave Vernor's the old exhibition hall for the location of its new plant. The new address would be 4501 Woodward Avenue. (Courtesy of the Burton Collection, Detroit Public Library.)

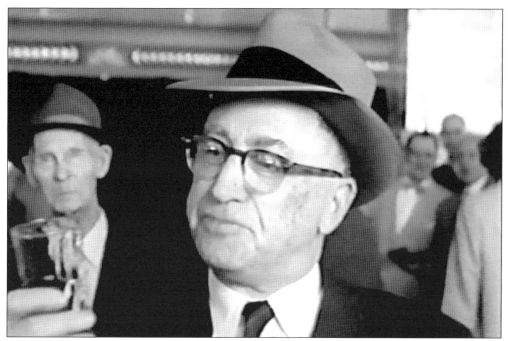

On the final day of operation of the Vernor's plant, James Vernor III, J. Vernor Davis, Mayor Cobo, and other dignitaries held a celebration in the soda fountain at the foot of Woodward Avenue. The location Detroiters had known and loved since 1896 would move considerably north on Woodward Avenue. This image comes from an old newsreel recording the event. Mayor Cobo is drinking a glass of Vernor's.

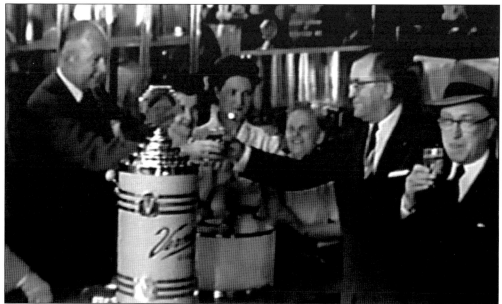

In another image from the same newsreel, James Vernor III serves a glass of Vernor's to Judge Frank G. Schemanske. The Vernor's counter girls watch the exchange. It was a day of mixed emotions as they left the plant that had been home to Vernor's since 1896. A beautiful porcelain dispenser is in the foreground.

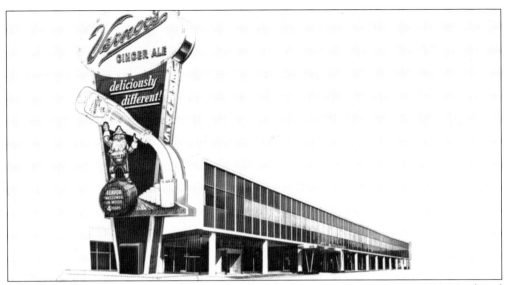

The new Vernor's plant was opened in 1954, north of the downtown Detroit area at 4501 Woodward Avenue. Visitors could stand outside the plant and watch the bottling operations from a span of large windows. Streetcars still rolled by Vernor's along Woodward Avenue.

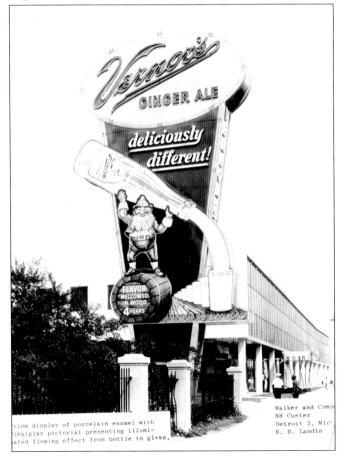

ylon display of porcelain enamel with
lexiglas pictorial presenting illumi-
ated flowing effect from bottle to glass.

Walker and Comp
88 Custer
Detroit 2, Mic'
E. D. Lamdin

The most famous part of the new Vernor's plant was the huge sign with the gnome out front. The sign stood 55 feet tall. It was first turned on at 9:00 p.m. on June 4, 1954. The sign was so big and generated so much heat with all the lights that it required its own air-conditioning system. (Vernor's is a registered trademark of A&W Concentrate Company. All rights reserved.)

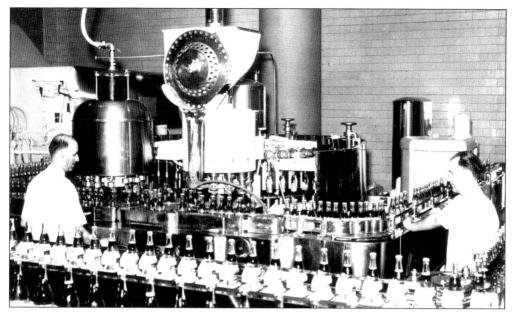

The new plant would not be able to use gravity like the old plant had done. However, it was famous for one of its architectural aspects, huge windows through which the bottling operations could be seen from the street. Here two men run part of the bottling operation.

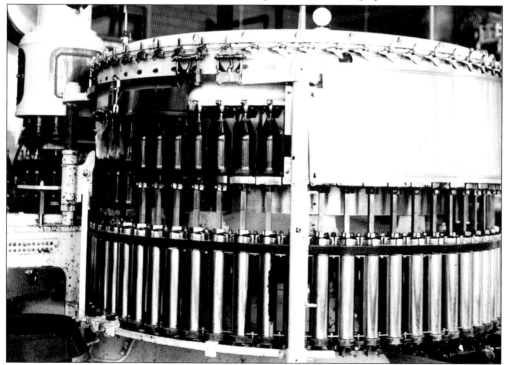

Vernor's Ginger Ale was always on the cutting edge of bottling technology. James Vernor II was the president of the bottling association for many years. Although he died just prior to the opening of the new plant, his father's insistence on perfection was passed down a generation. This bottling machine is one example of the modern and sterile environment.

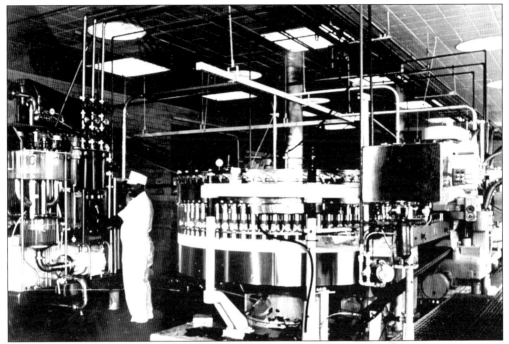

The factory was not limited to producing Vernor's Ginger Ale. This photograph shows the RC Cola bottling line in action. RC (short for Royal Crown) was bottled alongside Vernor's for many years. The outside of the factory even had an RC logo.

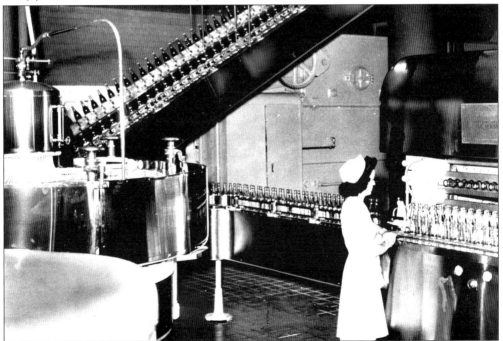

The Vernor's bottling operation was mainly automated. However, workers like this one were necessary to prevent and solve problems and to ensure quality. She is seen next to a bottle-washing machine making sure the process goes smoothly.

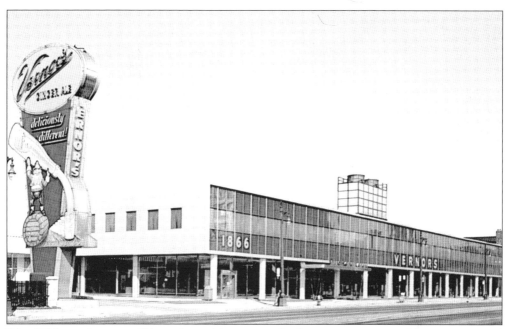

The 100th anniversary of Vernor's was bittersweet. As the company prepared for its centennial celebration, as shown in this postcard, the Vernor family sold off its stock to a group of New York investors. Although stock had been sold years earlier, 1966 marked the final days of family influence and control.

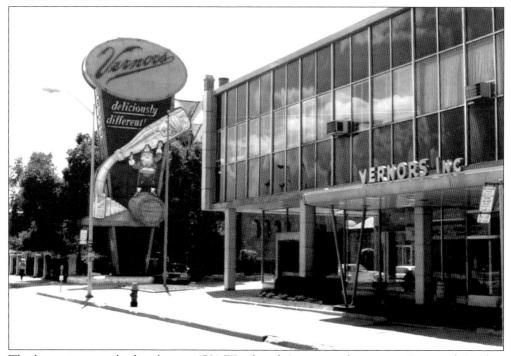

The huge sign outside the plant at 4501 Woodward Avenue no longer says "ginger ale" or has an apostrophe, but the gnome still proudly pours his bottle of Vernor's. The apostrophe was dropped in about 1959 when stock was first sold.

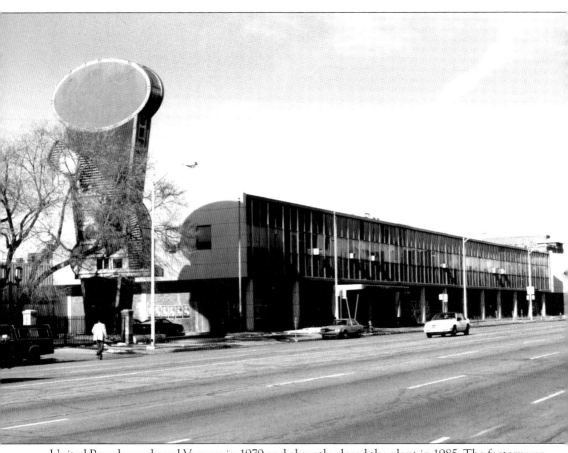

United Brands purchased Vernors in 1979 and abruptly closed the plant in 1985. The factory was boarded up, and much of the sign was dismantled. Even the RC was removed from the middle of the red square at the north end of the building.

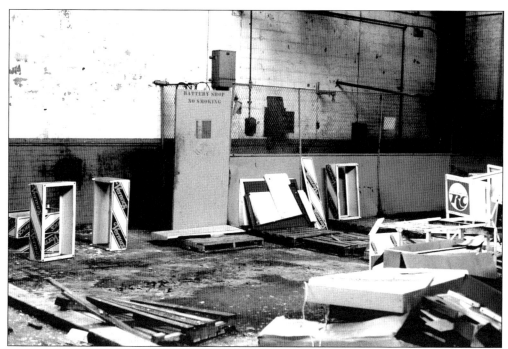

When United Brands closed Vernors, the plant was left in a mess. Bottling machinery was removed, but many other items remained and waited for the wrecking ball. Here Vernors and RC store displays are in piles.

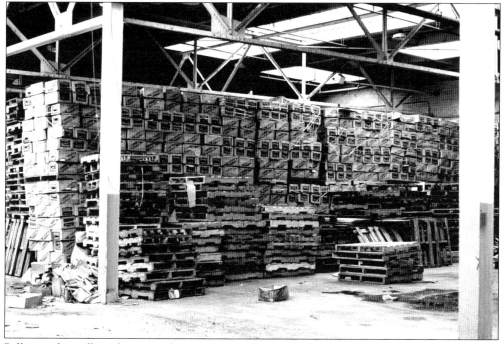

Pallets with cardboard cases and empty pallets numbered in the hundreds. The cardboard cases nearly reach the ceiling. All the materials were abandoned by United Brands and were destroyed when the plant was demolished.

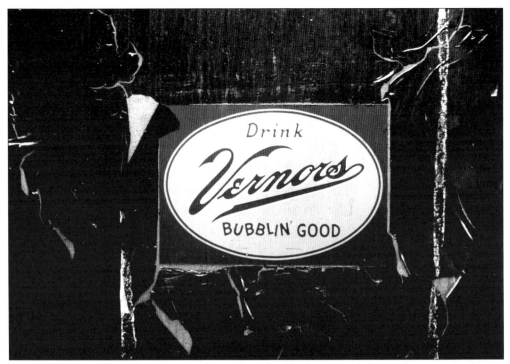

This Vernors sticker still looks brand-new, but the black paint of the surface on which it is attached is peeling. Vernors certainly did have a "Bubblin' Good" time in Detroit. From 1866 to 1987, Vernor's was the king of Detroit soda.

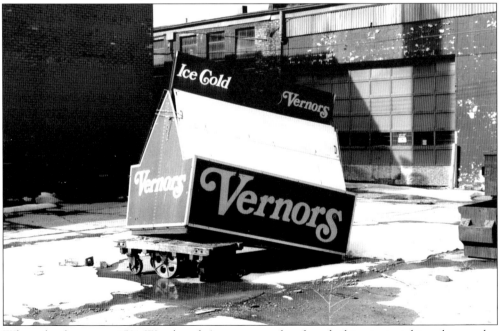

When the factory at 4501 Woodward Avenue was abandoned, this giant eight-pack was also left behind. Designed by artist Ron Bialecki, the unit was actually towed to special events. The interior opened up, and customers could get Vernor's from the unique eight-pack soda fountain.

Three

FIRSTBORN SONS

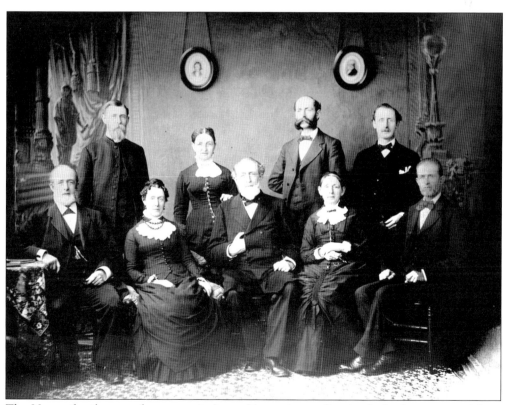

The Vernor family poses for a portrait. James Vernor is standing in the back row, second from the right. James Vernor was born on April 11, 1843, in Albany, New York. The family came to Detroit in 1848. James's father, John Taylor Vernor, was a bookkeeper in Albany. (Courtesy of the Burton Collection, Detroit Public Library.)

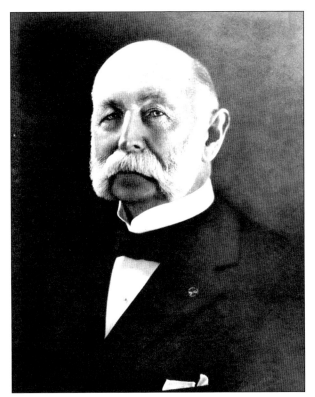

This very photograph hung on the walls of the Vernor's plant in fond memory of the founder of the company. James Vernor was known for his distinctive sideburns and moustache. He was also well known for his public work, such as serving as an alderman for the City of Detroit for many years.

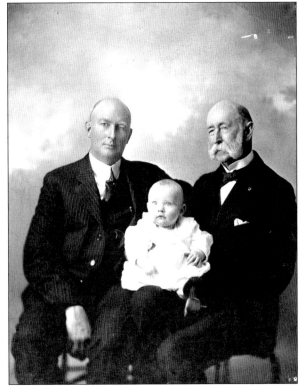

In 1877, James Vernor had a son, James. James Vernor II would follow in his father's footsteps and work in the family business. In 1917, James Vernor II had a son, James. James Vernor II and III were both firstborn sons of their parents. In fact, James Vernor IV, V, and VI were also all firstborn sons. This photograph of James I, II, and III must be from around 1919. (Courtesy of the Burton Collection, Detroit Public Library.)

James Vernor II entered the ginger ale business in 1896, yet he was not named president of the company until his father's death in 1927. James Vernor II watched over the company through a tremendous growth period. The plant at the foot of Woodward Avenue expanded to an entire city block under his leadership. He died in 1954, just before the official grand opening of the new plant at 4501 Woodward Avenue.

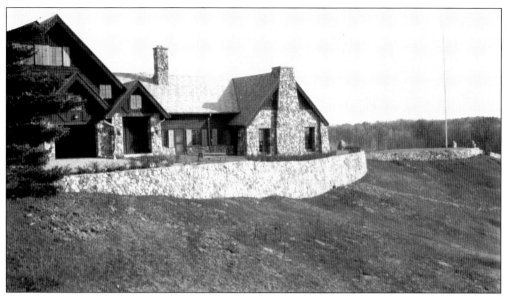

James Vernor II was an avid horseman and bred Thoroughbred horses at his 3,200-acre farm and ranch in Arcadia Township. In the early 1930s, he constructed a lodge on the property. He did not live there year-round. Vernor used the lodge as a place to entertain friends and business associates. The lodge had eight bedrooms, four bathrooms, three wood-burning stoves, and five eight-foot-wide fireplaces. These 1930s-era photographs show the exterior and interior of the lodge. (Courtesy of Sharna Smith, Arcadia Township offices.)

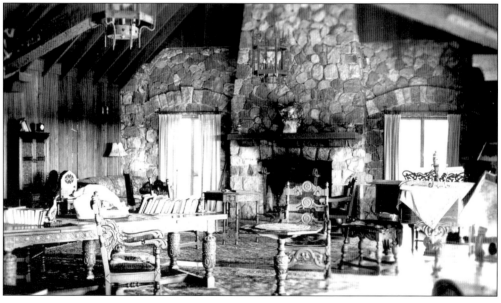

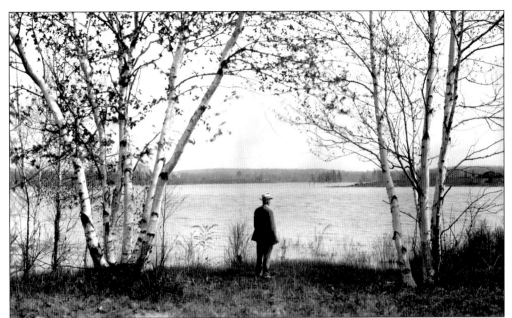

Both these 1930s-era photographs show James Vernor II at his property in Arcadia Township. In the photograph above, he enjoys the beauty and solitude of his lake surrounded by birch trees. He and his guests often enjoyed fishing on this lake. In the photograph to the right, Vernor stands with an unidentified man dressed in riding pants and boots, apparently ready for a day with his horses. On January 26, 1943, the lodge burned to the ground due to an electrical fire. In 1956, two years after Vernor's death, the State of Michigan acquired the land, and it is now part of the Lapeer State Game Area. (Courtesy of Sharna Smith, Arcadia Township offices.)

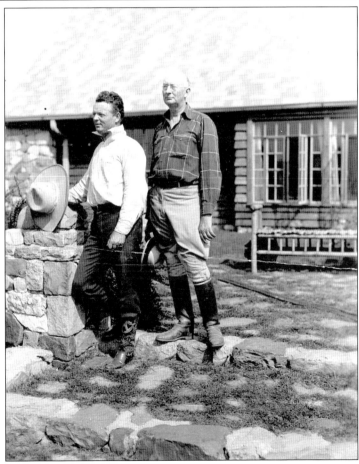

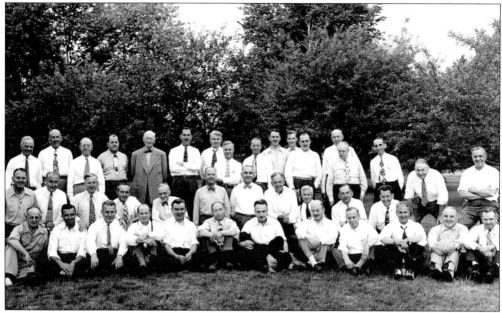

James Vernor II was a member of many organizations in the metropolitan Detroit area and beyond. He was a member of the Detroit Board of Commerce, Detroit Athletic Club, Detroit Boat Club, Bloomfield Hills Country Club, Moslem Shrine, and others. In this group photograph of the Detroit Executive Association, he is standing in the back row, fifth from the left. Harry T. Wunderlich, grandfather of the author, sits in the front row, the first person on the left. (Courtesy of Robert E. Wunderlich.)

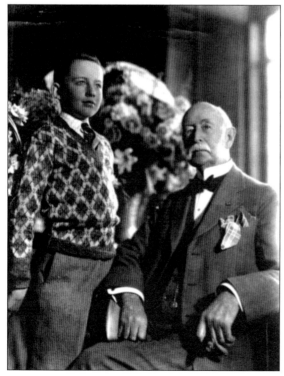

Grandfather Vernor is pictured with grandson J. Vernor Davis. Davis was older than James Vernor III and would take the presidency of Vernor's Ginger Ale in 1952. This photograph dates from approximately 1920.

James Vernor Davis was a grandson of James Vernor I, but through a daughter, not a son. For the Vernor name to carry on, he was given it as his middle name. Davis was older and would head the company before James Vernor III was given an opportunity. He became caught in some financial difficulties due to the death of James Vernor II in 1954 and would take the company public to raise cash.

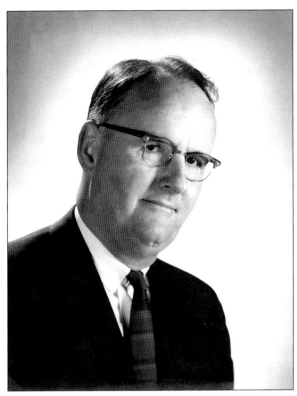

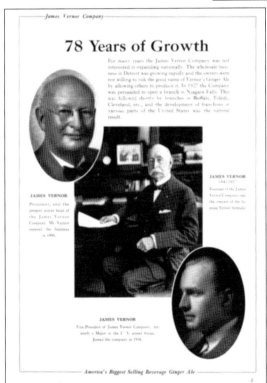

This page from a 1944 company sales manual pictures the three James Vernors. The narrative tells of a company that did not want to expand nationally for fear of losing control of the quality of the product.

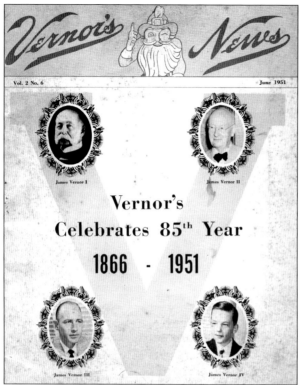

Seven years later, in June 1951, four James Vernors appear on the cover of *Vernor's News*, the company newsletter. Although he is only 11 years old, inside there is the expectation that James Vernor IV will move into company management. Little did they know that life for the Vernor family would change dramatically in the next seven years. By 1958, James Vernor IV would be the oldest living James Vernor.

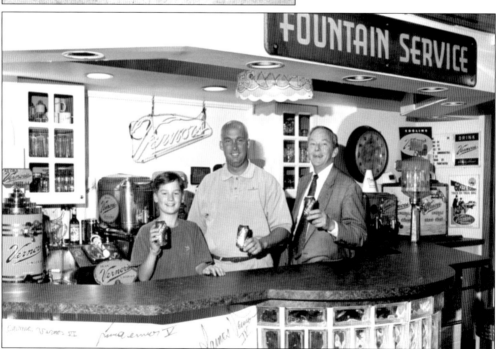

This 1999 photograph pictures three more James Vernors, all firstborn sons. From left to right are James Vernor VI, James Vernor V, and James Vernor IV. While they all enjoy drinking Vernor's, none are associated with the ginger ale business. (Photograph by David M. Maylen III.)

Four

THE GNOME

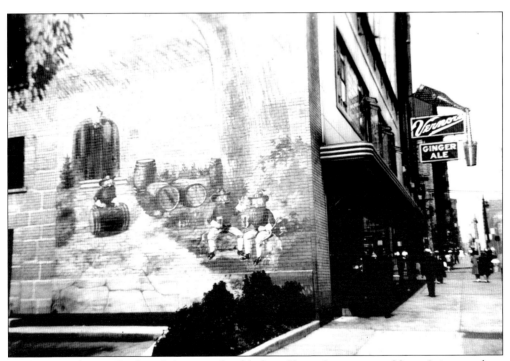

Looking north up Woodward Avenue, the fabulous Vernor's sign pours Vernor's into a glass. On the side of the building is a portion of the huge Vernor's mural. Two gnomes sit outside the Vernor's soda fountain enjoying a glass of Vernor's. This photograph, from the early 1940s, shows the main entrance to the soda fountain. The mural went as high as the fourth floor of the 10-story building. (Vernor's is a registered trademark of A&W Concentrate Company. All rights reserved.)

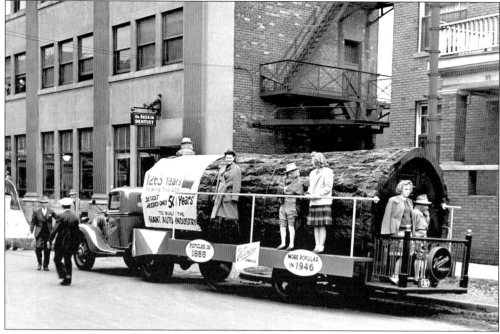

This 1946 photograph includes the famous Vernor's Wonder Log on a float for a parade. Most likely, this is the J. L. Hudson's Thanksgiving Day parade in Detroit. Three gnomes and three Vernor's Girls are visible on the float. There is often a notion that there was just one Vernor's gnome. Seeing three on the same parade float would be unusual. Yet there was never just one gnome. The murals in Detroit and Flint depict many gnomes. There are even some early advertisements showing multiple gnomes.

The gnome was everywhere. This 1940s photograph features the gnome on the side of one of the buildings in the Vernor's block in downtown Detroit. These same gnome signs appeared several places on the exterior of the Vernor's buildings.

Both the gnome and this Vernor's driver look happy. The gnome image was used on just about everything Vernor's. He has been on signs, bottles, cans, pens, pencils, key chains, bottle openers, paper cups, fountain dispensers, and even delivery trucks. (Courtesy of Superior View.)

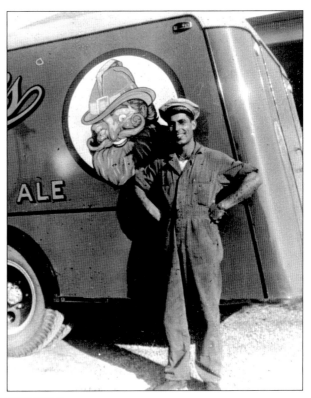

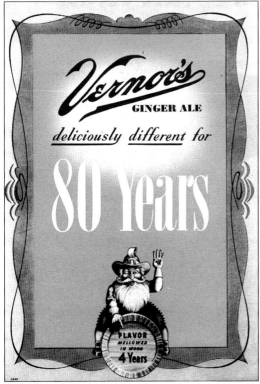

The 1946 celebration of the 80th anniversary of the James Vernor Company spilled over to its print advertising. In this full-page advertisement from *National Bottlers' Gazette*, the gnome sits in a familiar position straddling a barrel of extract. Above him, the huge "80 Years" is proclaimed. Many other similar advertisements were produced for other anniversary years, but the 80th brought out one of the biggest celebrations.

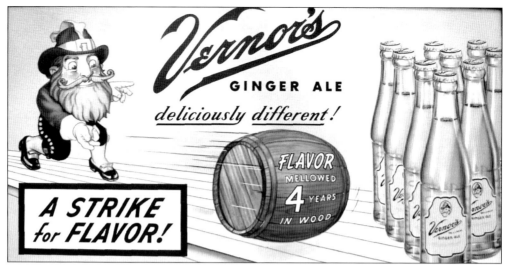

Vernor's produced a substantial amount of advertising using the gnome. The gnome frequently was sitting on a barrel of Vernor's extract. However, as these two photographs indicate, he could be involved in other activities as well. Whether it was bowling or serving a tray of Vernor's, there was never a doubt that the gnome would be part of the activity. (Vernor's is a registered trademark of A&W Concentrate Company. All rights reserved.)

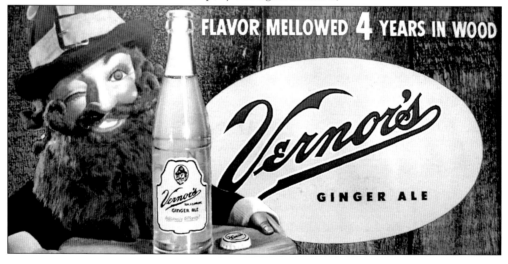

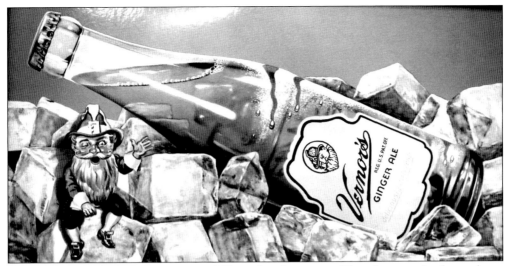

The gnome was a prominent part of Vernor's advertising. The photograph above shows him sitting on an ice cube. In the photograph below, the gnome strikes a pose as a painter. While there are several gnome advertisements with him as a painter, the gnome sitting on ice is unique. This advertisement also has an orange background, which is very unusual for Vernor's advertising.

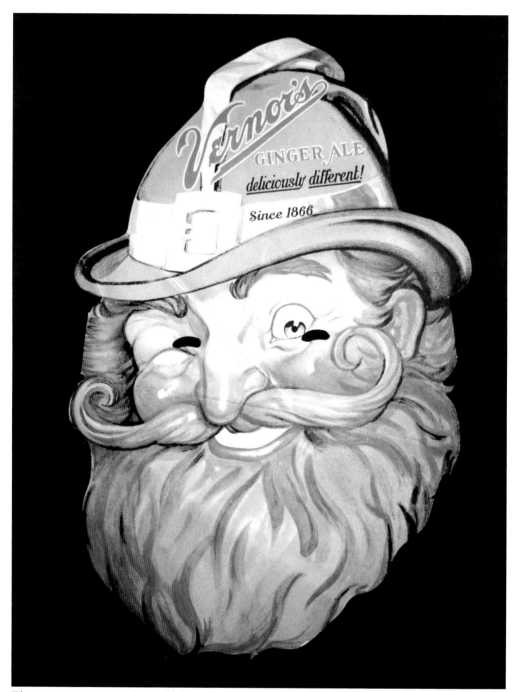

This paper gnome mask would have been a great Halloween costume. It is not known how children would have received a mask like this. It could have been something received at the end of the factory tour. It also could have been something the gnome himself handed out when he visited stores or schools.

The gnome was the third image that appeared on Vernor's bottles throughout the years. The first bottles carried an insignia that superimposed the letters VGA (for Vernor's Ginger Ale) on top of each other. Next came a delivery boy. Right around 1920, the Vernor's gnome was introduced. This photograph is of an early paper label for a bottle.

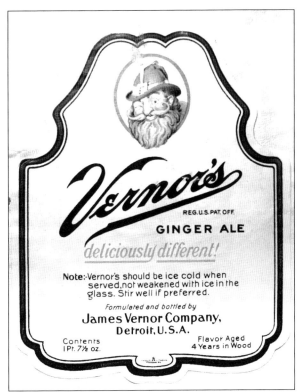

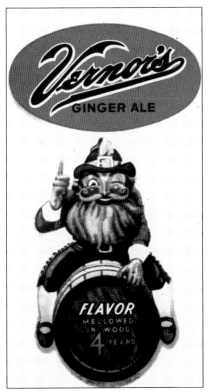

Probably the most familiar image of the gnome is when he is sitting on a barrel. This decal from the 1940s was one such image. A similar image was frequently found on signs.

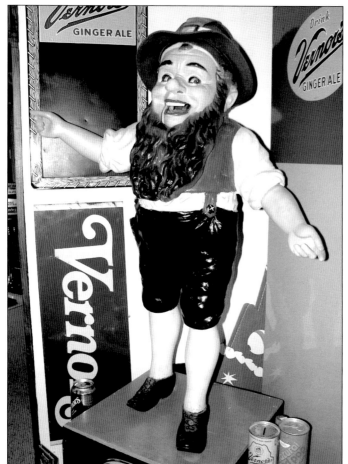

Tours of the Vernor's plant were narrated by mechanical Vernor's gnomes. Six of these mechanical gnomes were produced. They date from the early 1920s. The mouth moved up and down, and the eyes moved back and forth. They did not talk. Posters behind them explained the bottling process on the tour.

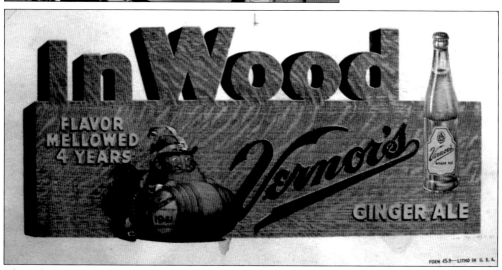

This advertisement is in the form of an ink blotter. The familiar gnome is there rolling a barrel of extract dated 1941. Although the gnome was usually winking, he must have been working so hard pushing the barrel that he needed to keep both eyes open.

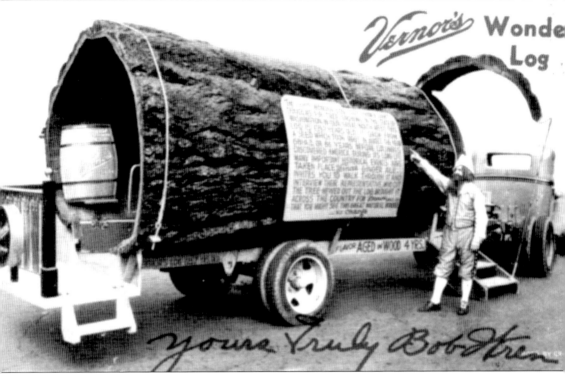

This postcard features the Vernor's Wonder Log. Many schoolchildren remember this log touring the Detroit area from 1938 to the early 1940s. The back of the postcard said the log is over eight feet in diameter, and it took six men 35 days to hew out the inside of the log. The actual base of the tree was over 15 feet in diameter but would not have been allowed on the road. Inside the log were glass cases with miniature representations of significant historical events in American history.

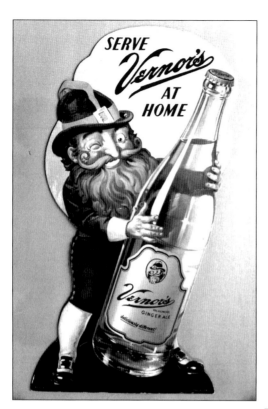

The most familiar design of the gnome is this one featured in a 1940s cardboard easel-back advertisement. The wink of his eye was as well known as the gnome himself. The earliest gnomes had both eyes open. In later years, whenever the gnome appeared he was winking.

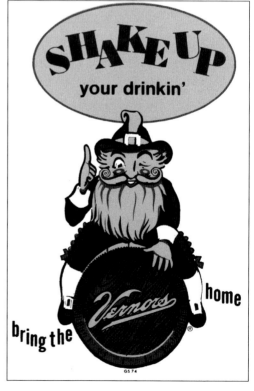

No matter what the slogan, the gnome was sure to be part of it. "Bubblin' Good," "Va-Va-Voom," "Vernor's for Vigor," "Deliciously Different," "Vernor's, for Experts and Learners," and this "Shake Up Your Drinkin'" slogan all featured the gnome. The gnome was always a consistent feature on everything Vernor's for many years.

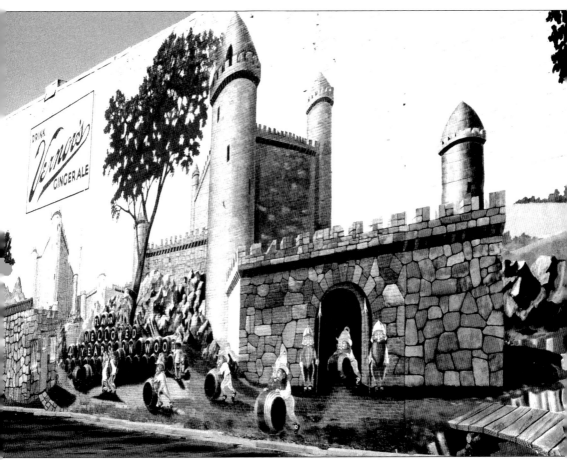

This huge mural in Flint covers the entire side of a building. This is the second mural that Vernor's had painted on the building. The first one was much less detailed. This version was first painted in 1932. It was renovated in 1979. In 1985, the building burned and was slated for demolition. The Greater Flint Arts Council, under the leadership of executive director Greg Fiedler, stopped the demolition and purchased the building. In 2005, the mural was renovated again.

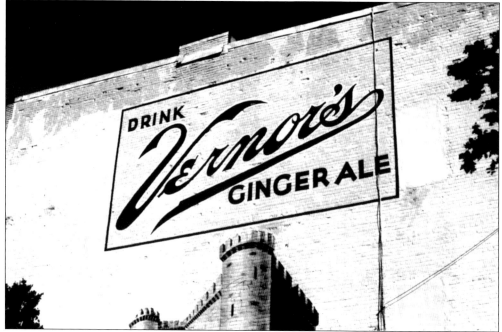

Above the castle was a large Drink Vernor's Ginger Ale sign. The sign could be seen prominently as people traveled Saginaw Street in Flint. The Vernor's soda fountain is gone, but the mural can still be enjoyed. The soda fountain building is now a Halo Burger restaurant.

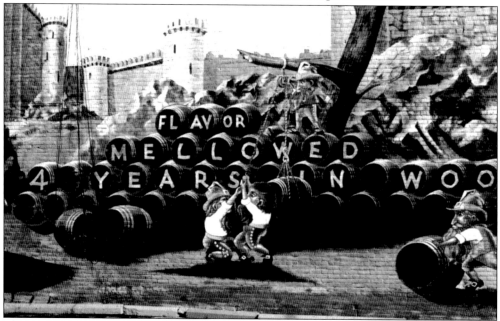

The mural has wonderful details of gnomes working on the production of Vernor's Ginger Ale. Here a gnome rolls a barrel of extract. In total, 14 gnomes appear on the mural. Each gnome has unique characteristics and a different purpose. Some gnomes are guarding the secret formula, others are mixing ingredients, still others are moving and storing the extract. One gnome is holding the banner crediting the original artist and those who did the renovation.

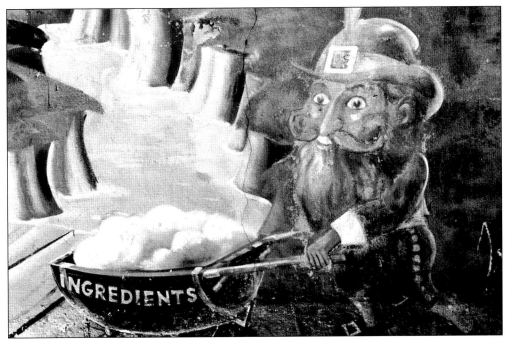

One detail of the mural depicts a gnome rolling a wheelbarrow of ingredients over a bridge. The most important job the gnomes had was protecting the secret formula. The mural was originally painted in 1932, was first renovated in 1979, and then renovated again in 2005.

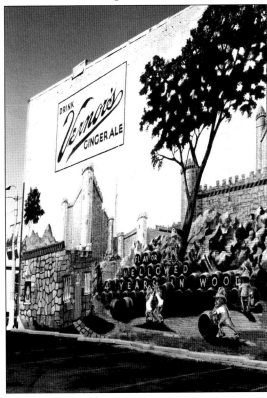

The Peerless Furniture Company is the building on which the mural is painted. The building itself was never a Vernor's property. Thanks to the Greater Flint Arts Council, it has been saved, and the mural is available today for the public to enjoy.

The image of the gnome went through many changes over the years. It always looked like a gnome, but different artists had different ideas of what he should look like. This 1970s gnome was one that looked much different than designs before or after.

This version of the gnome was designed by Ron Bialecki. The Vernor's Company was looking for a softer and friendlier version of the gnome. This design returned to a look similar to that of the 1940s, but with the multicolor printing costs of the 1970s in mind. A sticker, like the one pictured, might end up on a soda fountain dispenser or a soda pop machine. The design came in multiple sizes from 2 inches high to 10 inches high.

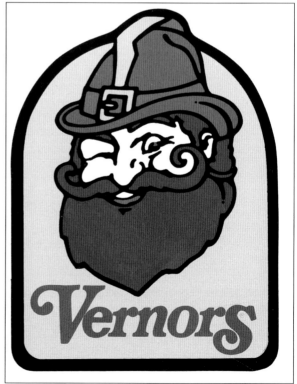

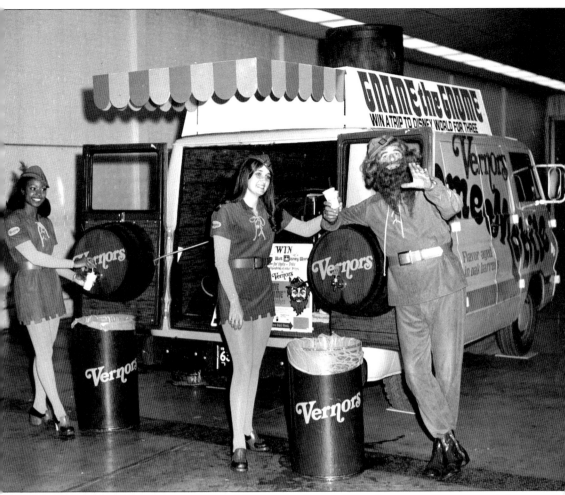

In the early 1970s, there was a contest to "Gname the Gnome." Two "gnomettes" accompanied a rather hairy-looking gnome to various locations around the Detroit area to run the contest. This photograph shows the Gnome Mobile parked inside a shopping mall. The van and the outfits were designed by Vernors artist Ron Bialecki. The outfits were sewn by his wife, Jean Bialecki. In the end, Jerome the Gnome won. A boy and his family won a trip to Disney World. (Courtesy of Ron Bialecki.)

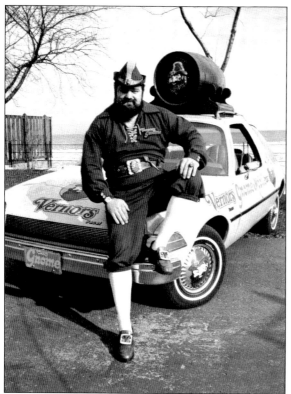

One of the more unusual vehicles the gnome ever drove was this AMC Pacer. All decorated as the Gnome Mobile, the gnome made appearances with it at stores and shopping malls. In addition to free samples of Vernor's, anyone coming up to the gnome could get an autographed photograph like this one. He would also hand out stickers and temporary tattoos. (Courtesy of Ron Bialecki.)

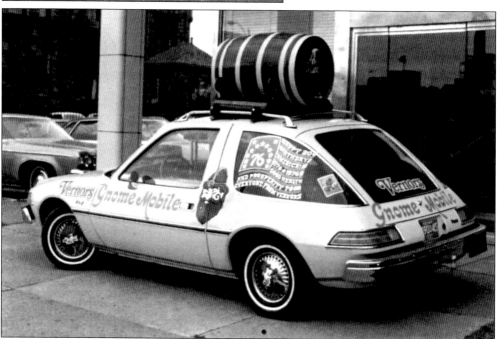

In this 1976 photograph, the Gnome Mobile is pulled up next to the Vernor's plant. The flag painted on the back window reads, "Happy 200 Birthday America 1776–1976, Good Health and Prosperity to Everyone from Vernor's." (Courtesy of Ron Bialecki.)

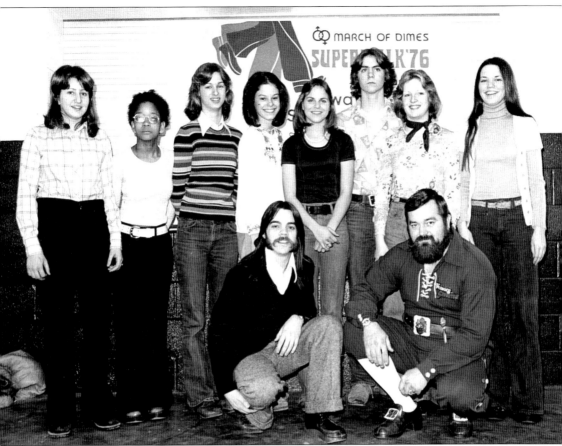

In 1976, Vernor's sponsored the March of Dimes walk in Detroit. Here a hatless gnome poses with kids who participated in the walk and a disc jockey from a radio station that was part of the sponsorship. (Courtesy of Ron Bialecki.)

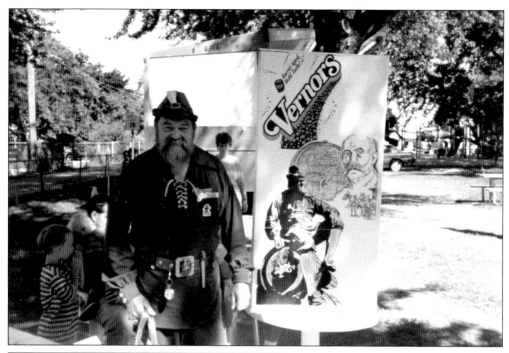

The gnome made many appearances at events across Michigan and Ohio. During the 1980s, the gnome image was removed from Vernor's packaging. In the 1990s, the gnome returned. In these two 1999 photographs, Ron Bialecki has returned in his role as the gnome. He has set up an autograph table, and free samples of Vernor's were available. (Courtesy of Ron Bialecki.)

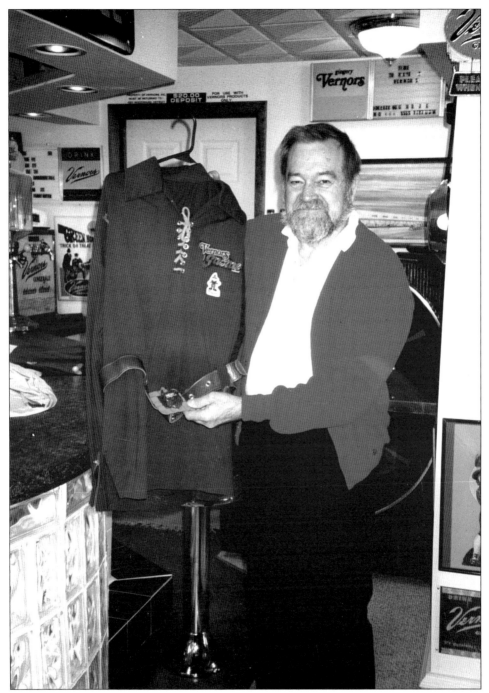

Ron Bialecki was hired by Vernor's as an artist. He first worked on a project to design the labels for a new line of natural flavors. He also worked on the design of the updated gnome. As he worked on the art, others at Vernor's remarked on how similar he looked to the gnome. They said he should play the part. He said, "No way!" It took about a year, and by 1975, Bialecki was playing the gnome. His wife, Jean, sewed a gnome outfit, and he began doing appearances. This photograph features Bialecki with his outfit in 2003.

This photograph was intended for retailers who sold Vernor's at their stores. A Vernor's salesman would offer retailers a variety of different items that could hold their store name while also advertising Vernor's. The salesman would show retailers photographs like this of the various options and then have one delivered to the store. This light-up sign from the early 1970s prominently featured the gnome.

When the plant at 4501 Woodward Avenue was demolished, certain pieces of the building were saved. Shawn Santo, owner of the Pure Detroit stores, obtained the gnome from the exterior of the plant. Pure Detroit opened its first store in 1998 and soon after acquired the sign. It has been housed in the Guardian Building store in downtown Detroit ever since.

Five

PROMOTING THE POP

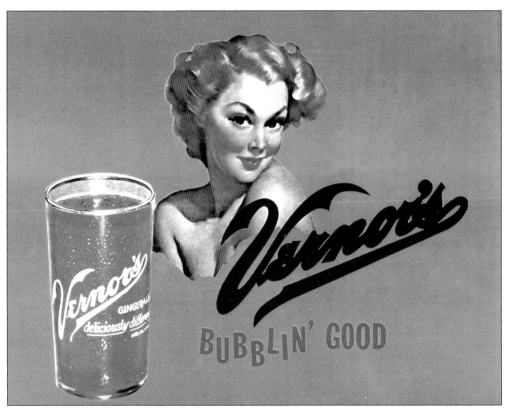

This particular blonde was used in many Vernor's advertisements. This advertisement was printed on translucent plastic so it could be lit from behind. The era is the 1940s, and this is the most "pinup girl" type of advertisement the company ever had. While there were many beautiful women used to promote the pop, the advertisements with this blonde were the most seductively posed and included the lowest-cut dress. (Vernor's is a registered trademark of A&W Concentrate Company. All rights reserved.)

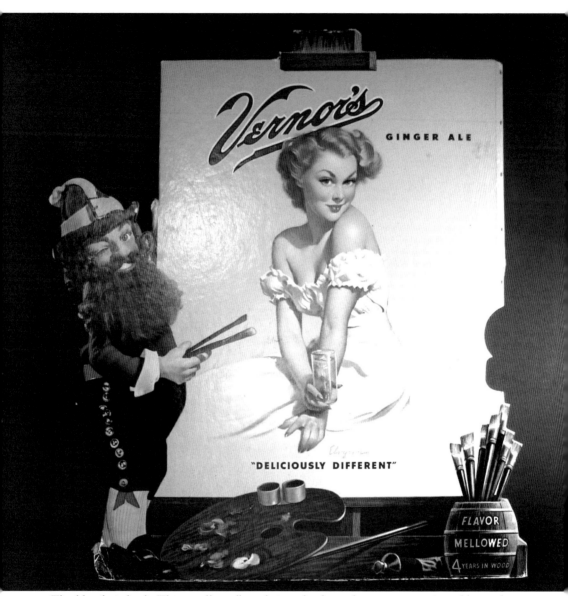

The blonde is back. This small cardboard sign also has a larger version. An additional version carries a calendar. Whatever the size or promotion, the gnome has done a beautiful job painting one of his favorite models.

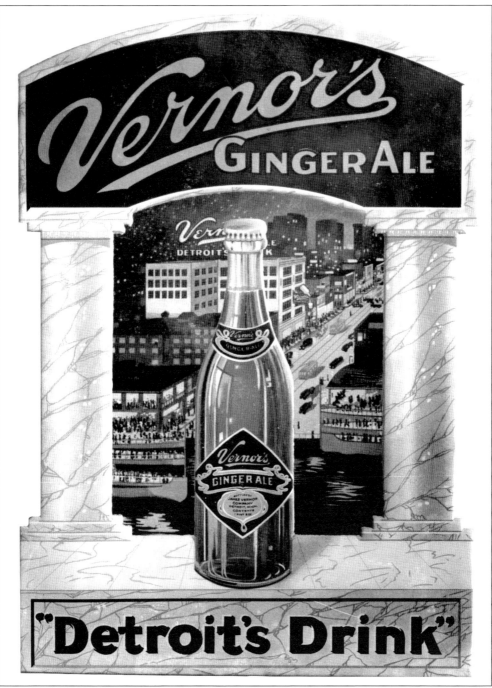

This early advertisement for Vernor's is an artist's rendering of the bottling plant at the foot of Woodward Avenue behind a bottle from before 1920. The huge illuminated sign on top of the factory did not look exactly like this, and the artist has conveniently left out a large building that was not yet part of the Vernor's plant. The artist successfully captured the crowds, the Bob-lo boats, and the excitement of being downtown. (Courtesy of the Manning Brothers Historic Photographic Collection.)

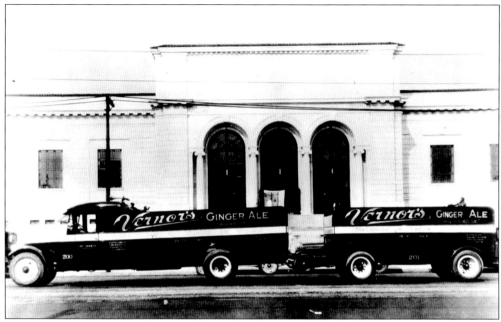

This impressive Vernor's delivery truck and trailer are parked in front of the Detroit Institute of Arts building along Woodward Avenue. This is the same style of truck and trailer used in the parade photograph on the cover. The capacity of this truck is quite large, and the truck is probably headed outside Detroit to a distribution center. This image dates from the mid- to late 1920s.

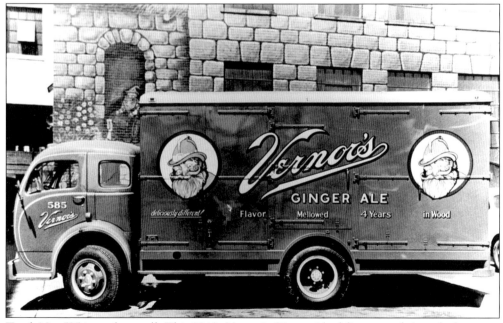

Truck No. 585 is ready to roll. This 1940s Vernor's Ginger Ale delivery truck is parked next to the mural at the Detroit plant. The promotion of the pop is obvious in many ways through this image. Three gnomes are visible along with the "deliciously different" slogan and the ever-present reference to mellowing the flavor four years in wood. (Courtesy of Superior View.)

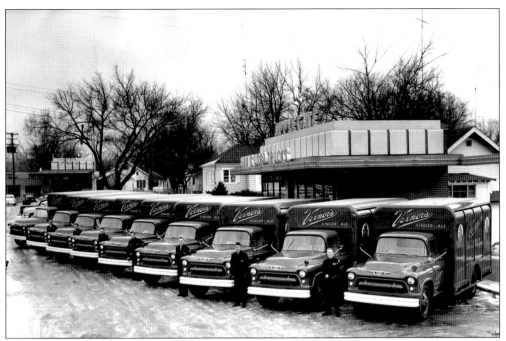

A new fleet of Chevrolet delivery trucks has arrived for the distribution center in Flint. This photograph was taken in 1956. Nine trucks stand ready for the next delivery of Vernor's. The drivers are all standing next to their shiny new trucks. (Copyright 1959 the Flint Journal. All rights reserved. Used with permission of the Flint Journal.)

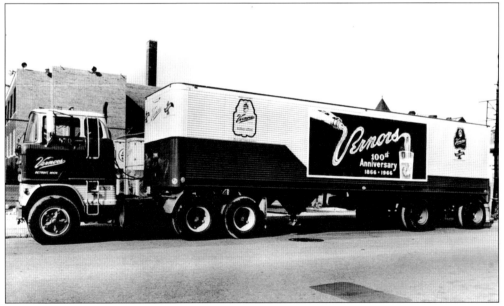

One of the first signs Vernor's used had a bottle tipped and filling a glass full of Vernor's. The 100th anniversary advertisement on the side of this truck adds another twist to the pouring by having the Vernor's logo spelled out before it reaches the glass. The year was 1966, and there was great celebration. That same year, however, Vernor's was sold to a group of investors and left family control forever.

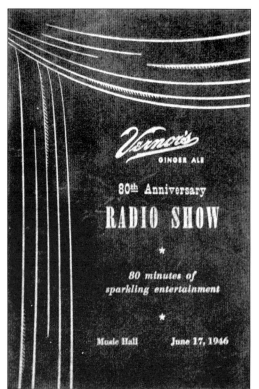

The James Vernor Company did many things one would expect a company to do when advertising its product. However, Vernor's also did the unexpected. In 1946, in celebration of the 80th anniversary of the company, it held a gala show at Detroit's Music Hall. Eighty minutes of entertainment were performed for WXYZ Radio. This program contained the acts of the show and biographies of many of the stars appearing in it.

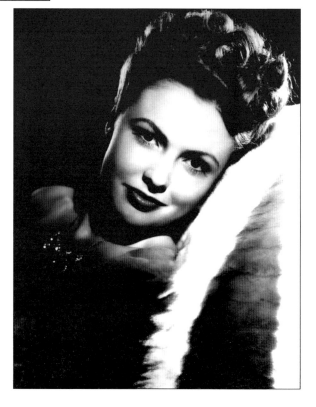

The biggest star of the evening was Joan Leslie. A native Detroiter, Joan Leslie was at the height of her career in movies when she returned to Detroit from Hollywood to star in the 80th anniversary show. Starring opposite Humphrey Bogart, James Cagney, Cary Grant, and Fred Astaire, her career spanned over 60 films. From 1941 to 1946, she made 18 films with MGM. On June 17, 1946, she was back in Detroit for Vernor's Ginger Ale. (Courtesy of Joan Leslie.)

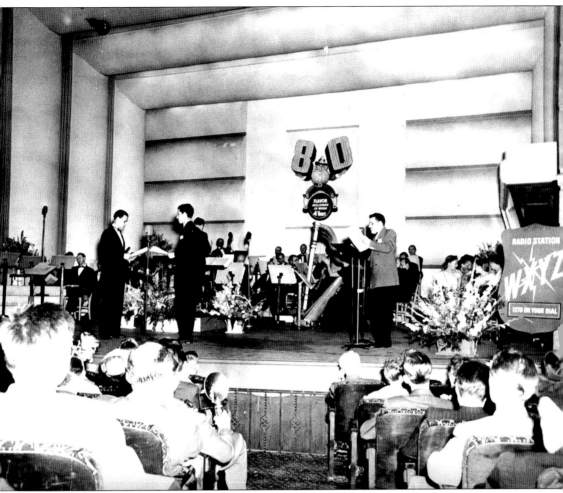

The stage of Detroit's Music Hall was filled with the Phil Bresthoff Orchestra, and as master of ceremonies, Jim Ameche ushered in the show. The show was a nostalgic look back at Detroit since 1866, when Vernor's was first created. There were mentions of Vernor's and James Vernor throughout the show, but it was not an 80-minute commercial for Vernor's Ginger Ale. It was more of a musical history lesson than it was an advertisement.

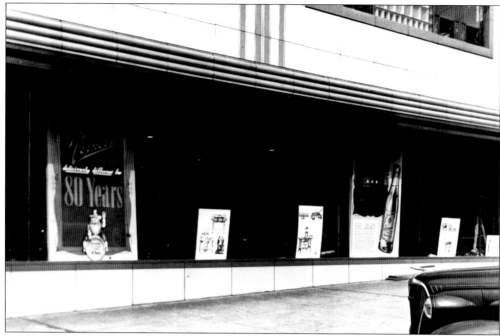

Signs were placed along the windows of the Vernor's plant to celebrate the 80th anniversary of the James Vernor Company. Two very large signs are visible with anniversary messages. The smaller signs seem to include illustrations of how Vernor's was made back in 1866.

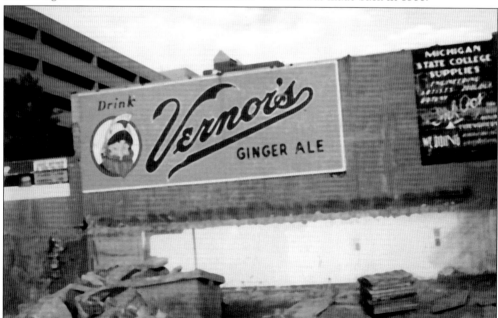

This Vernor's sign, with the gnome wearing a Michigan State University Spartan hat, was discovered in East Lansing when a building was demolished. The sign had been protected for many years. It became a media event when the sign was exposed in 2001 with several newspaper articles about it. The sign was dated approximately 1955. It was covered again when the new building was built.

Both these tin Vernor's signs are 4 feet high by 10 feet wide. These large Vernor's advertisements are four or five times the size of the advertisement for the store. It was a great way to advertise. The 1940s-era sign features the gnome rolling a barrel of extract. These same signs were often used on Vernor's distribution center buildings. A similar sign came in at least two smaller sizes. (Vernor's is a registered trademark of A&W Concentrate Company. All rights reserved.)

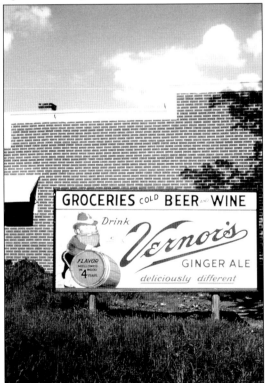

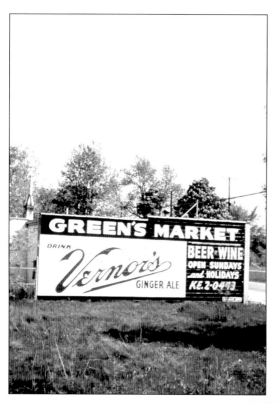

The tin signs were very large, but the painted signs were even bigger. Pictured are two different painted signs done by the Ashlee Sign Company. Green's did a better job of getting its own advertisement on the wall, but both Vernor's advertisements are at least six or seven feet high. It was a great deal for both Vernor's and the store owner. The owner received a painted wall with its name on it and Vernor's received a huge advertisement.

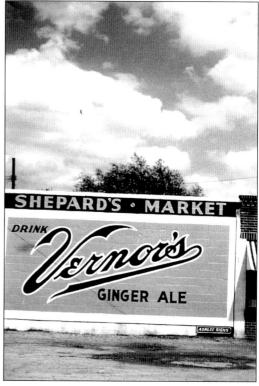

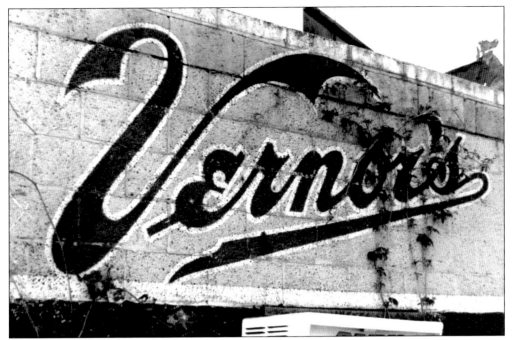

Vernor's painted its logo on walls throughout its distribution areas. Remnants of these signs can still be found today. Most signs, like the one shown in this photograph, were painted on the side of a store that carried Vernor's.

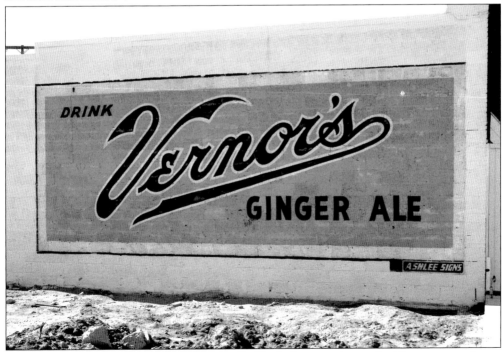

This Vernor's sign was recently discovered in Redford when an adjacent building was torn down. So impressed by the nostalgia of finding such an old Vernor's sign, rather than paint over it, the building owners had the sign restored.

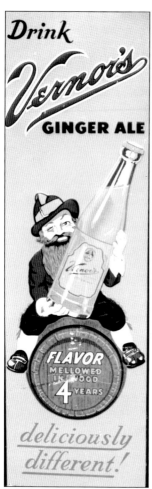

This image of a tin Vernor's sign shows one of the most collectible of all the gnome signs. It is 54 inches high by 18 inches wide. The sign dates from the early 1940s. A sign like this in mint condition is often the centerpiece of a collection. (Vernor's is a registered trademark of A&W Concentrate Company. All rights reserved.)

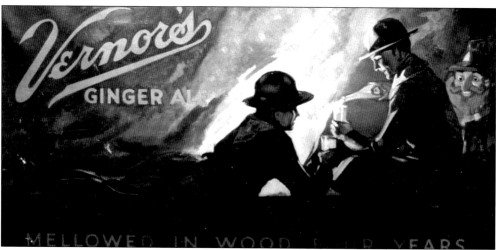

Boy Scouts are enjoying Vernor's at a campfire as the gnome looks on from behind. This cardboard sign first rode the streetcars of Detroit. Its size was meant to fit perfectly into the interior rounded corner above the windows of the streetcars.

Advertising companies created ideas for presentation to Vernor's executives in the hopes of selling the project. The artwork in these photographs is dated October 24, 1941. The same girl in the same pose appears in both. There is information on the index card next to both pieces of artwork that says neither had been produced. These photographs with notes were kept at the advertising agency to keep track of what work they had produced for various companies. Two favorites of Vernor's advertising are present. Both advertisements feature a pretty girl. One adds the gnome while the other adds "Aged 4 Years in Wood."

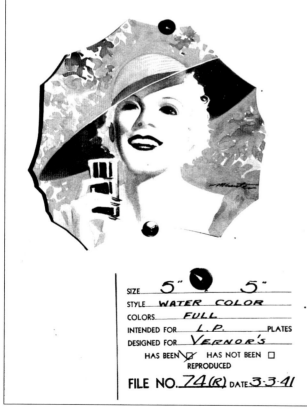

SIZE 5" 5"
STYLE WATER COLOR
COLORS FULL
INTENDED FOR L.P. PLATES
DESIGNED FOR VERNOR'S
HAS BEEN ☑ HAS NOT BEEN ☐
REPRODUCED
FILE NO. 74(R) DATE 3·3·41

Once again, Vernor's uses two pretty girls to attract the attention of customers. Both advertisements also show how happy customers could be if they only had a glass of Vernor's in their hand. The photograph above is a complete advertisement. It contains the Vernor's logo, the gnome and barrel, and a bottle so patrons recognized the product when they saw it on the shelf. The photograph to the left appears to be a piece of a larger advertisement. There is no logo, slogan, or any reference to Vernor's, even on the glass. Both images are from 1941.

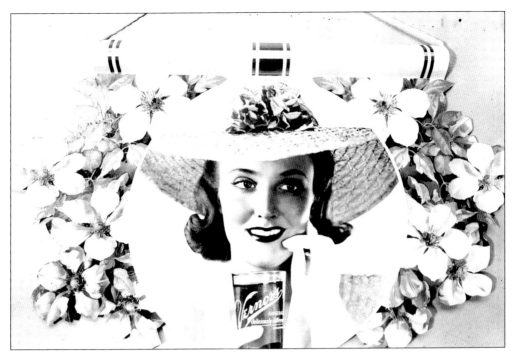

The James Vernor Company produced advertising that was made to be viewed through windows, for store displays, for standing on counters, and, as shown in this image, to be hung from the ceiling or on a wall. Notice the string on the top of this advertisement so that it could be hung. Flowers adorn her straw hat as well as surround her. There is no printing on this advertisement, but the glass says it all: "Vernor's Ginger Ale, deliciously different."

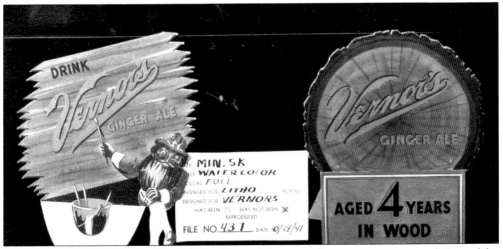

Two small counter cards depict another of Vernor's favorite advertising images, wood. One of the things that appeared frequently in Vernor's advertising was a barrel or some other reference to aging in wood. Both these small counter cards include the wood reference.

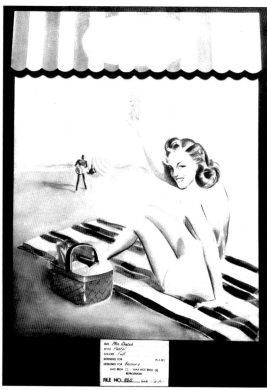

This artwork was completed in pastels, so it is lighter and less distinct than some of the artwork from the same advertising agency. Here a woman sits on the beach and holds up her bottle of Vernor's. Faintly across the awning above her, the Vernor's logo is visible. This was never intended to be a completed piece. It was the presentation of an idea for advertising.

This Vernor's sticker from the 1940s could be applied to just about anything. It might be on a door of a store, or it might be on the side of a soda dispenser. Throughout the years, Vernor's used a variety of stickers like this one to promote the pop.

Vernor's franchisees and retailers had their choice of which Vernor's advertisements they wanted. Each year a catalog of advertising choices would be published. A page, such as this one, would show retailers what was available for their store. This is a particularly interesting set of advertisements. Look closely at the various Vernor's logos. Some have an apostrophe and some do not. This is true on the same advertisement, like Santa with an apostrophe on the case but none in the wreath. Obviously this was during the transition from apostrophe to no apostrophe in the late 1950s. (Vernor's is a registered trademark of A&W Concentrate Company. All rights reserved.)

What was true of cardboard signs was also true for metal signs. Other pages within the catalog of advertising for the year contained photographs of metal signs. The franchisee wanted to make sure as many Vernor's signs as possible were put up at retailers' stores. Catalogs went so far as to show the proper placement of signs to get the most return on the advertisement.

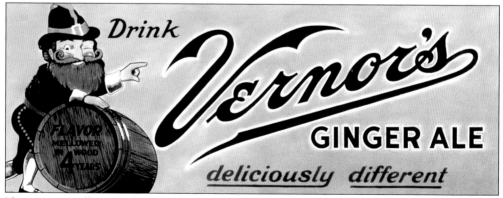

If a store was willing to advertise Vernor's, why not really advertise it. Billed as a 5-foot-by-10-foot roadside sign, a 4-foot-by-10-foot section of it was dedicated to Vernor's. The store owners could squeeze their name in on the top foot that was remaining. These great signs did attract quite a bit of attention. They could also be found on many distribution center buildings.

No. 10 10x30 in. Kickplate

No. 11B 14x40 in. Horizontal

No. 44 18x48in. Horizontal

No. 16 18x28in. Horizontal

No. 41 18x28in Horizontal

No. 23 11x36in. Horizontal

One of the most sought-after Vernor's signs is the one with the skyline of Detroit silhouette under the bottle. It is such a popular design that it has been reproduced in a smaller version. This page of advertising options features the skyline sign as well as a difficult-to-find On Draft sign. (Vernor's is a registered trademark of A&W Concentrate Company. All rights reserved.)

Buy a Case

Vernor's

GINGER ALE

EXTRACT MELLOWED 4 YEARS IN WOOD

The card pictured in this photograph is about the size of a business card. It must have been produced to encourage customers to return their empty bottles. A message on the back of the card says customers would receive a 5¢ rebate toward another case of Vernor's when they returned all their bottles.

This photograph comes from another advertising catalog for distributors and franchisees. Signs like this could be purchased by the dozen and given to stores and soda fountains within the distribution area. The cardboard countertop sign with an easel back shown is from the early 1960s.

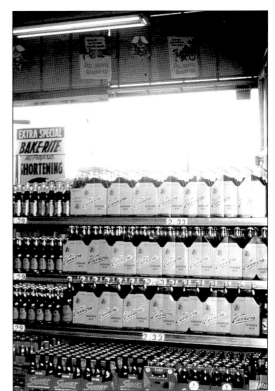

Both these images were intended to show retailers how this same type of Vernor's shelf display would increase sales at their store. At both stores, one could purchase two quarts of Vernor's for just 33¢. If a customer wanted 12-ounce bottles instead, the one store was a whole penny cheaper at just 29¢ for six bottles. It is nice to see Vernor's having way more shelf space than Coke back in the 1950s.

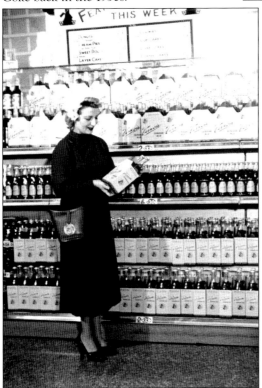

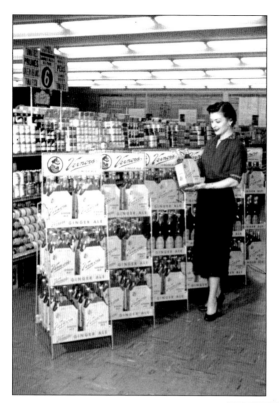

This wonderful store display certainly made Vernor's stand out from the rest. Six bottle racks full of Vernor's quart bottles are set up right in the middle of the aisle. A sign on the back wall shows that this is an A&P market. Vernor's hoped this photograph would interest other markets to display Vernor's in the same way.

This fabulous window display has many great Vernor's advertisements in it. There are 10 different cardboard advertisements and a total of 19 advertisements in the display. A great deal of effort also went into coordinating the background in the Vernor's green and yellow colors. This photograph was used to show retailers what could be done in their store windows.

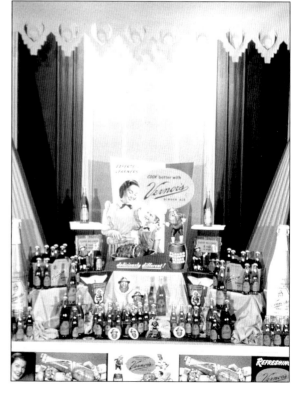

It would be difficult to miss this Vernor's display from the late 1940s. Six cardboard advertisements are visible in addition to at least 35 cases of quart bottles and another 40 two-pack quart containers. Salesmen and drivers were responsible for setting up the displays. Frequently Vernor's would feature the best displays in its company newsletter.

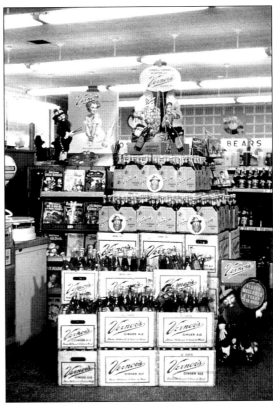

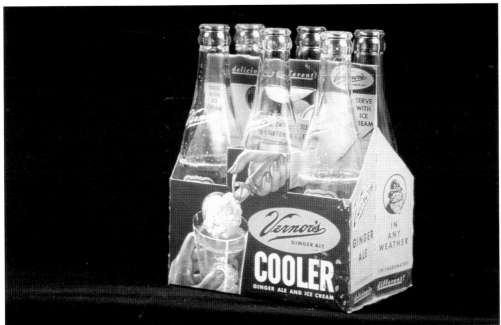

The number of different bottle holders used over the years is too numerous to count. Scores of different designs were utilized to gain attention on the shelf or to advertise different ways to use Vernor's. Serving suggestions were commonplace on six-pack containers.

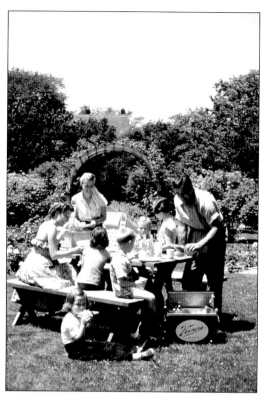

These two photographs were originally stereo slides that a salesperson took to show retailers through a battery-operated slide viewer. This looks like a picnic in someone's backyard. The images were intended to show the retailer how much families enjoyed their Vernor's Ginger Ale. The picnic basket must not have been too full. The kids only have a peanut butter sandwich. But there is plenty of Vernor's in the cooler.

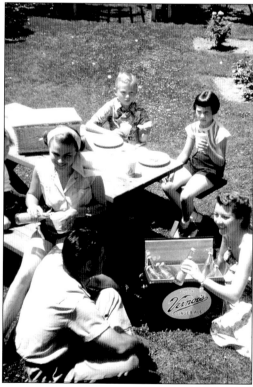

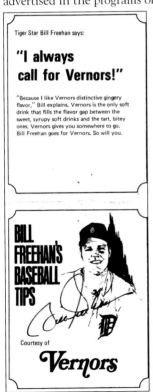

In the late 1960s and early 1970s, Vernor's stepped up its use of well-known personalities in its advertising. Pat Paulson, Ted Nugent, Chuck Daily, and sports figures like Detroit Tiger Bill Freehan were included in advertising. The Bill Freehan promotion included photographs, like the autographed one to the right, and a baseball tips brochure, like the one below. Vernor's frequently advertised in the programs of sporting events.

Tiger Star Bill Freehan says:

"I always call for Vernors!"

"Because I like Vernors distinctive gingery flavor," Bill explains. Vernors is the only soft drink that fills the flavor gap between the sweet, syrupy soft drinks and the tart, bitey ones. Vernors gives you somewhere to go. Bill Freehan goes for Vernors. So will you.

BILL FREEHAN'S BASEBALL TIPS

Courtesy of

Vernors

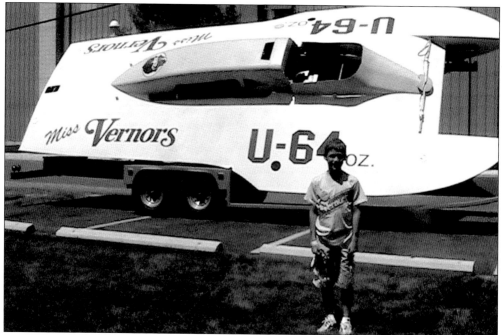

In addition to Vernor's Ginger Ale, Detroit is also famous for the Gold Cup hydroplane races every summer on the Detroit River. In the 1970s, Vernor's sponsored a hydroplane in the races. Two different hull designs were used over the years. This photograph shows *Miss Vernors* on a trailer in 2005 partially through a renovation project.

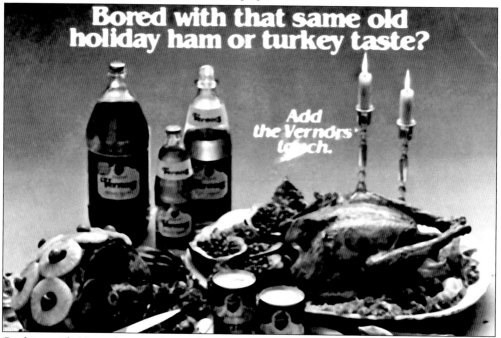

Cooking with Vernor's was a theme that went back to the early days when recipe books were distributed with everything from Vernor's gelatin to holiday ham glaze. This early-1980s photograph was intended to be a shelf talker, displayed right along with the Vernor's.

Six

PRODUCTS AND
POSSIBILITIES

James Vernor II was a
wise businessman. He
saw the ever-increasing
sales of Canada Dry as a
mixer and thought about
competing in that market.
His father, James Vernor I,
was against alcohol
and would never have
approved of a ginger ale
mixer. The death of James
Vernor I in 1927 and the
end of Prohibition in 1933
combined to lead Vernor
to produce both a dry
ginger ale and sparkling
water as a mixer. The
brand name came from
the location of his farm in
Arcadia Township.

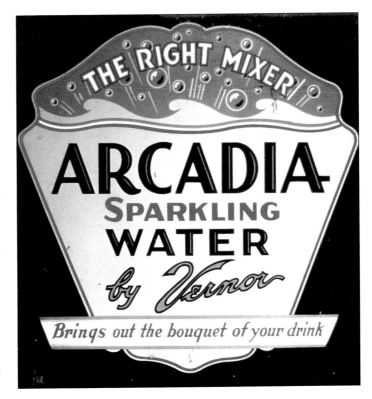

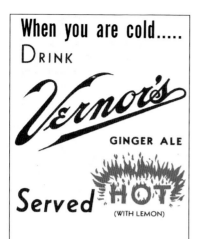

When you are cold.....

DRINK

Vernor's

GINGER ALE

Served HOT!
(WITH LEMON)

Here's a treat as original and surprising
as the famous VERNOR'S flavor itself.
Heat VERNOR'S to the boiling point
in a glass or metal container, then pour
over a small piece of lemon. It's espe-
cially welcome on a cold day after out-
door activity.

Printed in U.S.A. Form 45

When it is cold outside, drink Vernor's hot. That slogan
appeared on many advertisements and promotions
throughout the years. Vernor's even produced special
containers in which to serve Vernor's hot. If the cold
winter months happened to cause a sore throat, mothers
everywhere knew a nice cup of hot Vernor's would
help their children feel better. (Vernor's is a registered
trademark of A&W Concentrate Company. All
rights reserved.)

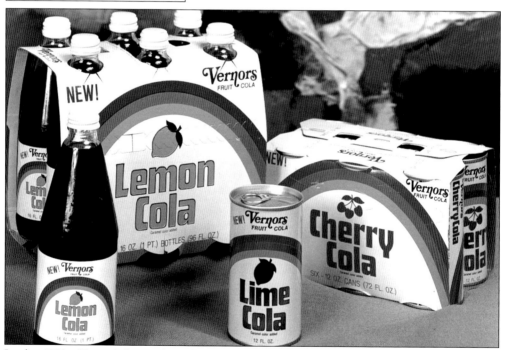

In the 1970s, Vernor's began branching out into other flavors. The products were ultimately
not successful. Little did they know that they were simply a bit ahead of their time. Customers
were not ready for cherry or lemon cola back then, yet store shelves are full of examples today.
Vernor's also tried orange, red pop, and lemon-lime.

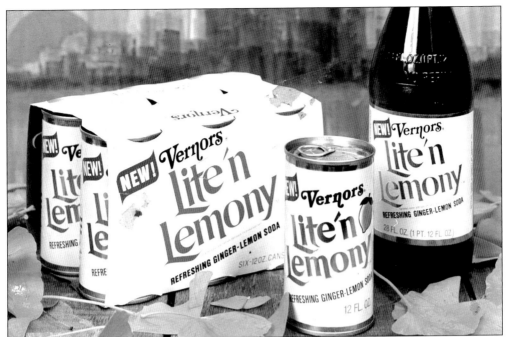

This promotional photograph was for a different flavor of Vernor's. Lite 'n Lemony added a touch of lemon to the popular Vernor's flavor. As more and more calorie-conscious drinks hit the market, the addition of a "lite" soda along with diet Vernor's would be a sure hit. Customers, unfortunately, wanted anything that said Vernor's on it to taste just like Vernor's. Sales of the expanded product line were not high enough to warrant continuation.

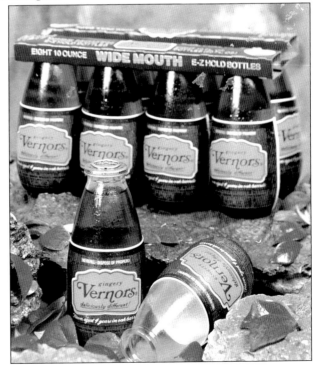

Sometimes a person does not need a whole 12-ounce or 16-ounce bottle of pop. Sometimes eight ounces will do. These smaller wide-mouth bottles were very popular, and designs other than the one shown in this promotional photograph were used throughout the years.

There is no doubt this promotional photograph was taken in the mid-1970s. The clothing and photographic style depict the era before the 1970s Vernor's packaging is noticed. This photograph may have been associated with some other youth-oriented advertising that included television advertisements featuring rocker Ted Nugent.

Throughout the years, Vernor's advertised with food. There are advertisements with Vernor's and hamburgers, Vernor's and steak, Vernor's and sandwiches, or Vernor's and snacks. Every time, the advertisement had a purpose to show customers how well Vernor's goes with food. This photograph from the mid-1970s connects Vernor's with pretzels.

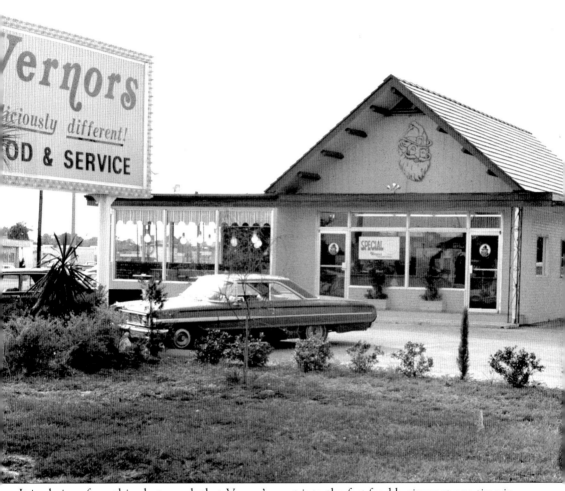

It is obvious from this photograph that Vernor's went into the fast-food business at one time in its history. From the palm trees outside, it is also obvious that this location was not in Detroit. One of the largest bottling facilities outside Detroit was in Tampa, Florida. Vernor's also had a bottling facility in Miami. The location of this restaurant is unknown. However, Florida is on the top of the list of guesses. (Vernor's is a registered trademark of A&W Concentrate Company. All rights reserved.)

121

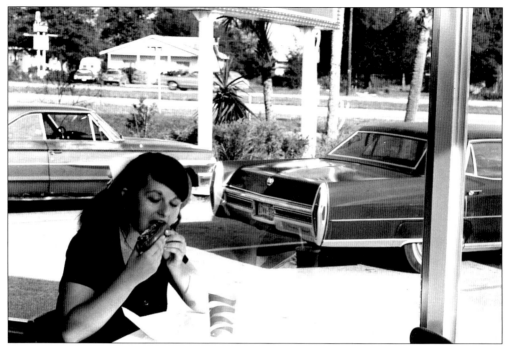

The automobile outside has a Florida license plate and a "Vernors for Vigor" bumper sticker. The green and yellow building serves some typical restaurant fare, like the Coney dog the young woman is eating. The feature, however, is not what one eats but what one drinks.

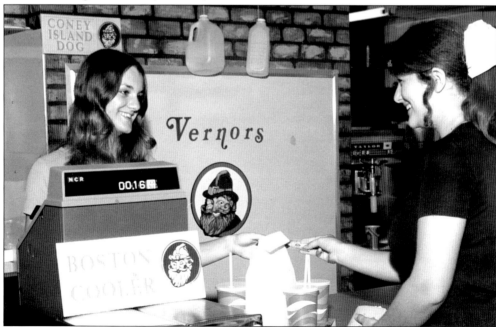

Inside the Vernors Restaurant, the true reason for the restaurant is evident. Boston Coolers, Vernor's floats, and other Vernor's recipes are available. The gnome looks on as customers come to the counter. This was a great attempt to re-create something similar to the soda fountains of earlier days.

In the early 1970s, Vernors had a big idea. It wanted to open 200 ice-cream shops under the name Vernors Big Scoop. The first one opened in Warren in July 1973. Cream-ales and Boston Coolers would, of course, be standard fare. Vernors Big Scoop would also have a "do your own thing" ice-cream bar for sundaes. This photograph is an artist's rendering of the exterior of the store.

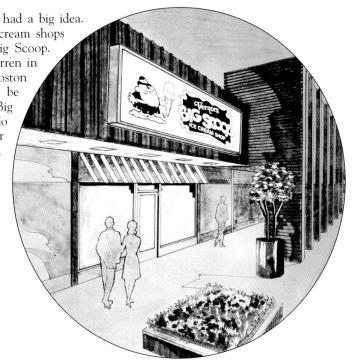

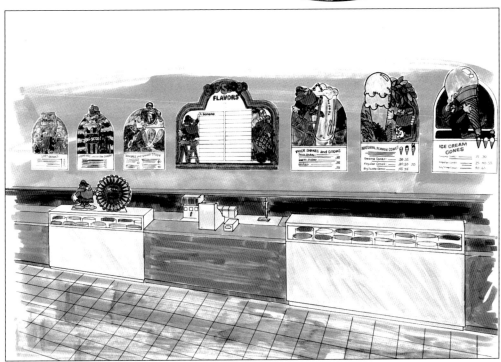

The interior of Vernors Big Scoop Ice Cream Shop is shown in this photograph of an artist's rendering. All the menus, the signs, and the store itself were designed by Ron Bialecki. Bialecki worked for Vernors as an artist and, in 1975, would begin playing the part of the Vernors gnome.

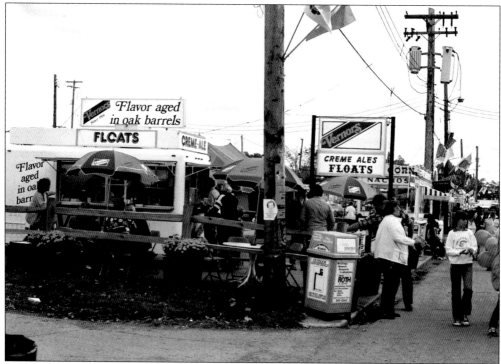

Both the images on this page were taken at the Michigan State Fair in the mid-1980s. A Vernors Ginger Ale refreshment trailer has been set up featuring an area of tables with Vernors umbrellas. Two of the favorite Vernors recipes were available here: Vernors floats and an oddly spelled cream-ale. Even the flower planters being used here were made out of old Vernors extract barrels. Coincidently, the Michigan State Fair is also located in Detroit on Woodward Avenue.

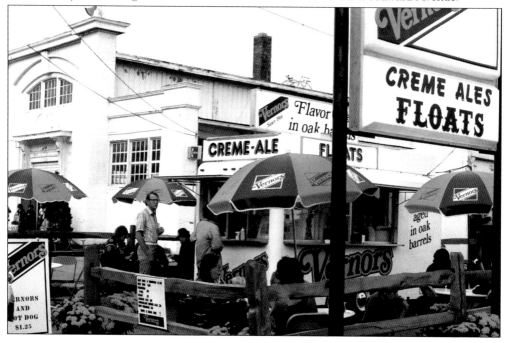

This purple 1999 Chevrolet Tracker was one of a pair of cars that went around to local Vernors promotional events. This customized Tracker contained a massive sound system that filled the entire back of the car. The cars would park at a shopping mall or skating rink and hold a series of competitions, such as putting a golf ball. Winners would walk away with a Vernors T-shirt. All participants would get coupons or a temporary tattoo. Author Keith Wunderlich is shown in this May 1999 photograph.

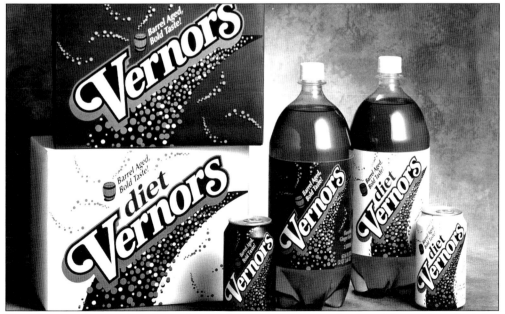

This photograph must have been for an advertisement or a trade show. Vernors launched this logo design in 1996. Here two 12-packs and two-liter bottles are perfectly positioned to show off the new design. (Vernor's is a registered trademark of A&W Concentrate Company. All rights reserved.)

Vernors frequently produced pages like this one with artwork for advertisements. Each page contained a variety of sizes of the same image. The local bottler or franchisee could then choose the right size image for the advertisement they would run in the local newspaper.

This is another example of image pages for advertisements. This time, a wide variety of half-liter bottles are shown. Franchisees could literally cut and paste the images to create an advertisement for their bottling area.

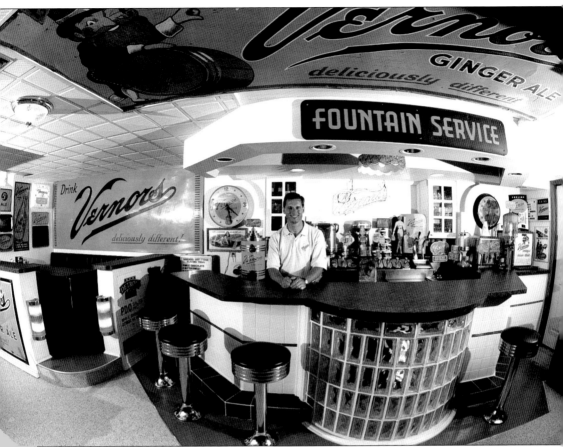

The Vernors plants on Woodward Avenue are gone. But the memory of Vernor's in the hearts of people across the United States and Canada lives on. A club for collectors of Vernor's Ginger Ale memorabilia exists and shares great Vernor's history and advertising with its members. Inquiries about the club can be sent to vernorsclub@yahoo.com. Vernor's Club founder Keith Wunderlich is pictured with a portion of his collection. (Photograph by David M. Maylen III.)

www.arcadiapublishing.com

Discover books about the town where you grew up, the cities where your friends and families live, the town where your parents met, or even that retirement spot you've been dreaming about. Our Web site provides history lovers with exclusive deals, advanced notification about new titles, e-mail alerts of author events, and much more.

MADE IN THE USA

Arcadia Publishing, the leading local history publisher in the United States, is committed to making history accessible and meaningful through publishing books that celebrate and preserve the heritage of America's people and places. Consistent with our mission to preserve history on a local level, this book was printed in South Carolina on American-made paper and manufactured entirely in the United States.

This book carries the accredited Forest Stewardship Council (FSC) label and is printed on 100 percent FSC-certified paper. Products carrying the FSC label are independently certified to assure consumers that they come from forests that are managed to meet the social, economic, and ecological needs of present and future generations.

FSC
Mixed Sources
Product group from well-managed forests and other controlled sources

Cert no. SW-COC-001530
www.fsc.org
© 1996 Forest Stewardship Council

Find Your Place in History.